IMAGES
of America

NORTHERN
OSWEGO COUNTY

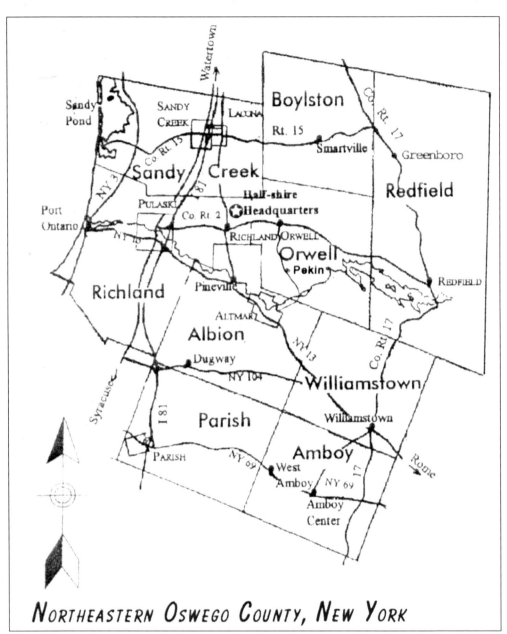

NORTHEASTERN OSWEGO COUNTY, NEW YORK

Oswego County is easily found on most maps, as it is situated on the shores of Lake Ontario and borders Oneida Lake on the south. The county was separated from Oneida County in 1819. The northern nine townships of Oswego County agitated for a separate county in early years, but in the 1850s, the issue was settled by declaring the county to be a "Half Shire County" with two county seats, one in Oswego City in the west and the other in the village of Pulaski in the northeast. This book highlights pictorially the history of the northeast region and its people.

IMAGES
of America

NORTHERN
OSWEGO COUNTY

Half-Shire Historical Society

ARCADIA

First printed in 2003.

Published by Arcadia Publishing,
an imprint of Tempus Publishing Inc.
2A Cumberland Street
Charleston, SC 29401

Printed in Great Britain.

Library of Congress Catalog Card Number: 2003107810

For all general information, contact Arcadia Publishing:
Telephone 843-853-2070
Fax 843-853-0044
E-mail sales@arcadiapublishing.com

For customer service and orders:
Toll-free 1-888-313-2665

Visit us on the Internet at www.arcadiapublishing.com.

On the Cover: Civil War veterans are pictured in front of the Olmstead store in Orwell in 1886. Orwell sent more than 184 of its sons to fight in defense of the Union. Years later, the Grand Army of the Republic lodge had an Orwell chapter that met regularly and contributed to the civic good of the community and the welfare of its members and families. From left to right are the following: (front row) unidentified, Cyrus Stowell, Henry Stowell, Allen Bonner, two unidentified men, John J. Hollis, and unidentified; (middle row) Albert Potter, unidentified, ? Nelson, William Presley, Ed Stevens, unidentified, ? Kingman, Charles Myers, and A.E. Olmstead; (back row) Horace Parker. Barely visible in the left window are Fred Olmstead and Charles Stevens.

CONTENTS

INTRODUCTION

Northeastern Oswego County has always had a distinct identity of its own. The authors of this book decided that it was time to showcase this unique region of nine communities that make up the Half-Shire historical region. The project was a team effort, with wonderful cooperation from all involved in assembling the best possible collection of historical photographs.

Albion once was filled with flourishing farmlands and mills. The railroad that intersected the township brought in goods while exporting Albion's products of lumber, dairy, and other farm goods. Florence Gardner, Albion's very active historian, compiled material for Chapter One.

Amboy lies in the southeastern portion of the region. It has maintained some very good farmlands and extensive timber resources. Historian Lucille Dunn and Ed Lescinski contributed many valuable images and supporting data for Chapter Two.

Boylston lies in the north and is a hilly land of deep woodlands that produce maple sap and timber. The farms of the previous two centuries supported large, hard-working, religious families of great industry and strong faith. Boylston historian Rita Rombach was assisted by Norm Widrig and Phyllis LeBeau in selecting the images and data for Chapter Three.

Early doctors throughout the region recognized and sent people to Orwell to breathe the clean, crisp air as part of a cure for lung ailments. Orwell has a history of sturdy family farms, neat little hamlets, and, for nearly 90 years, a large portion of the Salmon River Reservoir—now being utilized for recreation. Shawn Doyle worked with Half Shire materials to compile Orwell's images for Chapter Four.

Parish marked its bicentennial of settlement in 2003. For Chapter Five, members of the town's active historical society, led by Linda McNamara and historian Bridgett Swartz, spent countless hours selecting the diverse images that best portray the families and structures so important in the town's past.

When people hear of Redfield, they may recall the deep snowfalls that attract national attention yearly. An active group of current and former residents led by Shawn Doyle has been involved in a multivolume history project since 2000. The photographs for Chapter Six have been carefully selected to represent the history of Redfield, the largest town by acreage in Oswego County.

Pulaski, a village in the town of Richland, is the location of Oswego County's oldest courthouse. For Chapter Seven, Pulaski Historical Society members Mary Lou Morrow and Ken Smith along with Sara Barclay have carefully selected images to reflect the well-documented history of the town. To support these selections, George Widrig, a meticulous researcher who focuses on the hamlet of Richland and the earliest families of northern Oswego County, and Andy Gibbs shared photographs and information.

Sandy Creek separated from the town of Richland in 1825; yet, the town has been settled since 1803. Historian Charlene Cole is a descendant of some of the town's earliest settlers. For Chapter Eight, she took care to present a mix of images from the villages of Sandy Creek and Lacona, and from the hamlet of Sandy Pond, as well as rural scenes that reflect on the region as a whole.

Williamstown historian Glenna Gorski and her husband, Richard Gorski, shared some wonderful images from their extensive collection for Chapter Nine. The hamlet of Williamstown has a rich history as a railroad stop for lumber, agricultural goods, and the products of several small cottage industries. In their heyday, the fine hotels of Williamstown were well known among railroad travelers.

All images were prepared by Jim Shutts, and the text was reviewed by Sara Barclay, Charlene Cole, and Shawn Doyle in consultation with historians.

More information on Half-Shire and affiliated historical societies is available from Half-Shire Historical Society, P.O. Box 73, 1100 North Main Street, Richland, NY 13144; Halfshire@hotmail.com; http://community.syracuse.com/cc/halfshire.

One

ALBION

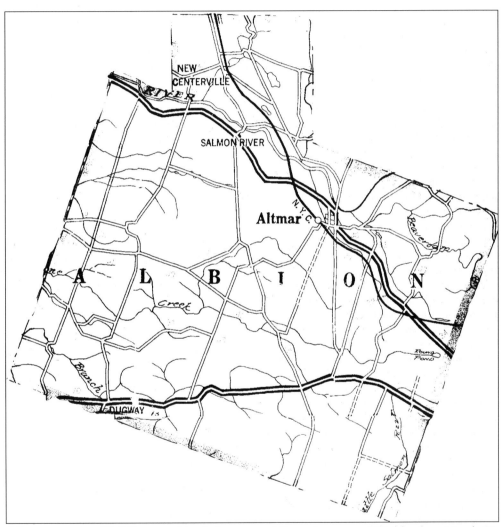

Albion comprises 30,457 acres of land. It separated from the town of Richland on March 24, 1825. Six hamlets grew within the township in the early 1800s. Sand Bank, now called Altmar, was the largest and became the seat of local government. Dugway and Howardville were located in the southern portion of the town, and New Centerville was in the northern section. Fraicheur was in the east, and Salmon River, now called Pineville, was in the west. Early settlers were drawn to the area because of the dense forests that covered the land. Within a short span of time, a very profitable lumbering industry grew. By 1860, there were 38 sawmills throughout the town. An early plank road crossed the town, and later, a railroad, which ran until the mid-20th century.

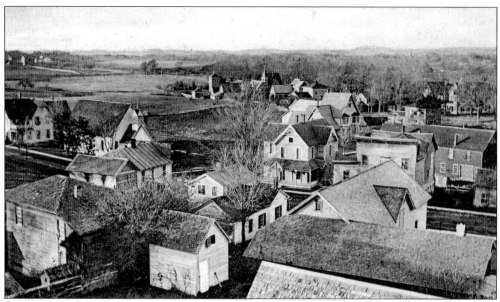

Late-19th-century Altmar, or Sand Bank, as it was known then, was a bustling industrial town. It was incorporated on February 21, 1876. By 1880, its population had grown to some 600 people.

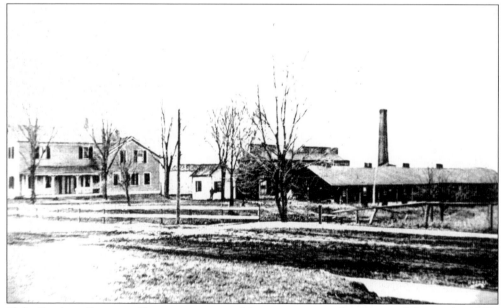

Flohr Brothers Company Tannery was one of the six tanneries that operated during the 1800s in Altmar. On September 13, 1900, this tannery and its entire stock were destroyed by fire. The loss was estimated at $125,000.

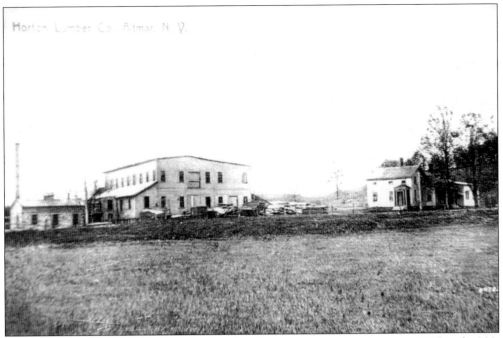

Byron Horton established the Horton Lumber Company sometime between 1875 and 1880. When his sons, Chase and Percy, came of age, they took over the business and operated it until a fire destroyed the old landmark on December 27, 1940.

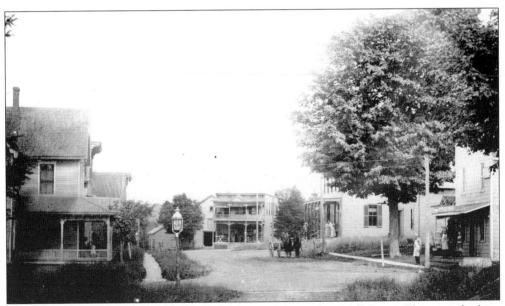

Many of the businesses in the village of Altmar were located on Mill Street. This view, looking east, shows a meat market and Steele's general store on the right. On the left are a private home, Campbell's feed mill, and the Altmar Hotel. At the far end is V.D. Pierce's furniture store and undertaking parlor. The tannery was at the western end of the street.

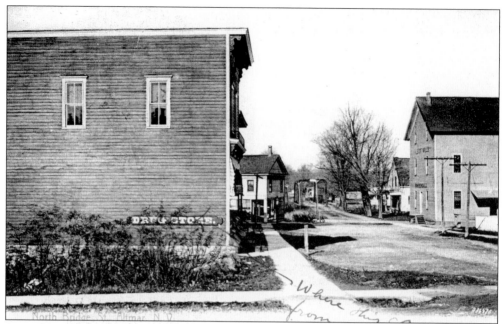

Several businesses were located on Bridge Street. In this view, looking north, the feed mill is on the right and the drugstore is on the left. The town hall (not visible) is beyond the Fradenburgh drugstore.

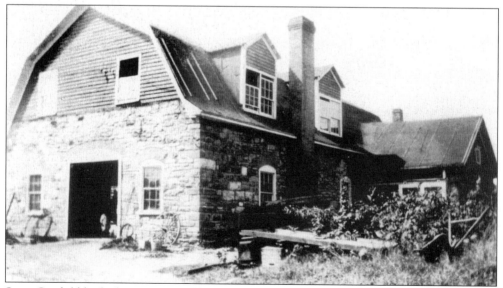

Scott Canfield built this impressive blacksmith shop *c.* 1900.

Scott Canfield (1851–1938) was of the many blacksmiths to locate in the town of Albion.

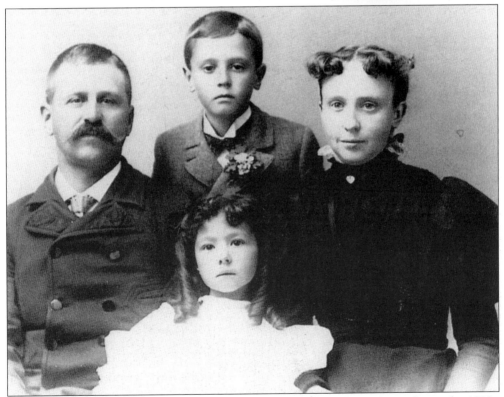

William Davis and his son, John, were wagon and carriage makers in Altmar during the 1800s. Shown are John Davis and his wife, Edith, with their children, Chester and Orla Mae.

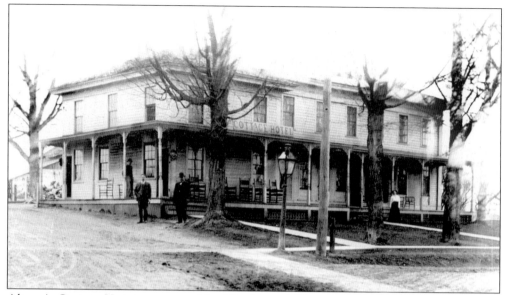

Altmar's Cottage House was owned by Charles and Theresa (Moore) Falvey, originally of Florence. The Falveys operated the establishment until 1913, when they sold out and moved to Redfield. This building burned on March 17, 1917.

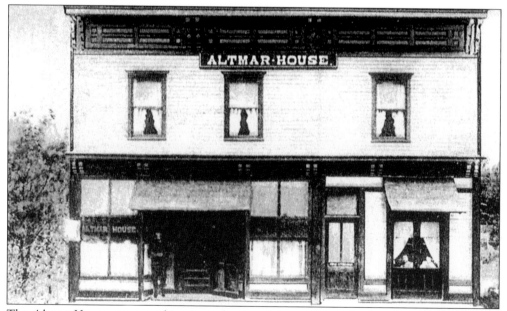

The Altmar House was a combination saloon and restaurant on the first floor and had rooms for rent on the upper floor. There were two entrances, one for men and one for women. After the building burned on February 19, 1989, a smaller one was built on the site. Today, the establishment continues the long tradition of serving the public.

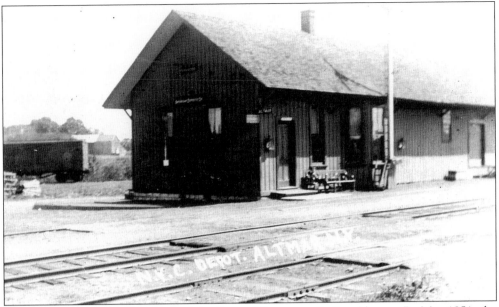

In November 1848, construction of the Rome–Watertown Railroad began. By May 1851, the line had been completed through the village of Altmar. The depot was built in 1852 and was in use until the early 1950s.

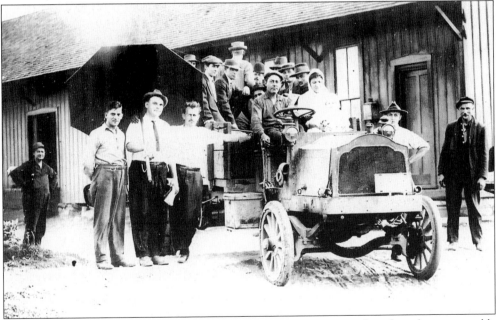

This vehicle was one of the modes of early transportation across the often dusty or muddy streets of Altmar to and from the depot in the early 1900s.

Labeled "Out for a Sunday drive," this view shows the Teachout family traveling across Dugway's "sand dunes." This region was known as "Arabia" for its sand, which tended to drift across the plank road. Sometimes the sand on the road got so deep that a snowplow had to be brought in to clear the way.

David Fradenburgh, the local pharmacist, built this home in the late 1800s. He was responsible for having many of the early photographs of Altmar taken. He sold the pictures as postcards in his drugstore.

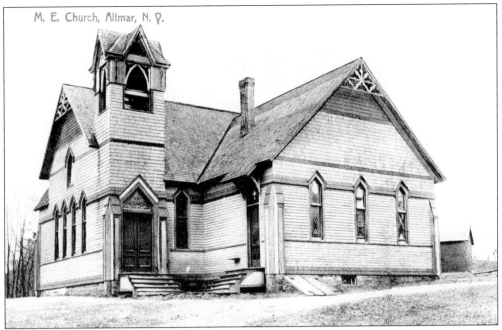

M. E. Church, Altmar, N. Y.

Of the seven churches built in the town of Albion, only two Methodist congregations remain active today. Pictured is the Riverside United Methodist Church in Altmar, built in 1895.

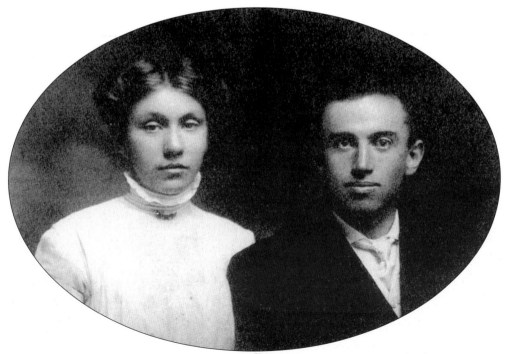

Alta and Sherman Kennedy are pictured. Reverend Kennedy was a Methodist minister in Altmar in the early 1900s.

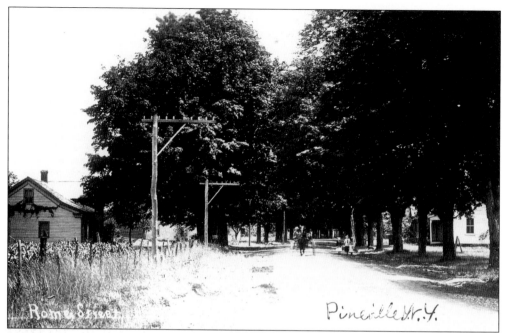

Rome Street Pineville N.Y.

This is the main road through Pineville. The hamlet of Pineville was first called Pineville Square, then Salmon River, and finally just Pineville. As the name implies, an abundance of trees drew people in the lumbering industry to this area. Squire John Rice was one of the first settlers. He constructed a sawmill on the Salmon River, which runs through the center of the township.

Shown is the Rice homestead, which was owned by Squire John Rice of Pineville.

The dedication of the Civil War Monument, on June 14, 1911, was the biggest celebration to have ever taken place in Altmar. The Honorable Thomas M. Costello, a former resident, gave the monument to the town to honor the more than 300 men who served in the war; 56 of them were killed, and many others were disabled.

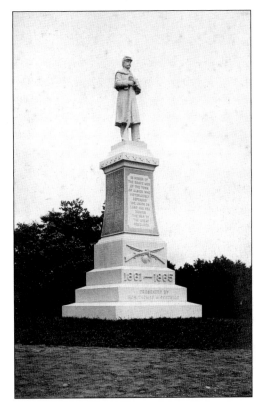

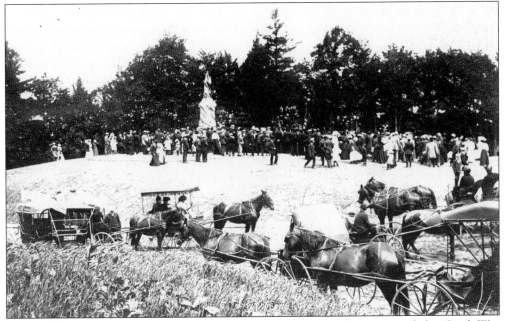

The crowd gathers at Altmar's Riverside Cemetery for the dedication of the Civil War Monument on June 14, 1911.

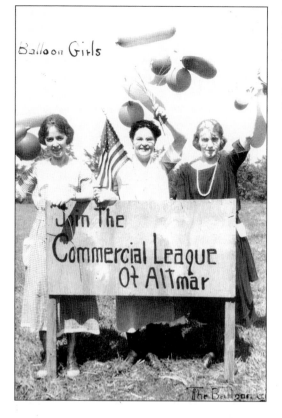

The request is to "Join the Commercial League of Altmar." The Commercial League was one of the many organizations that thrived in Altmar during the early 1900s. From left to right are Mae Campbell, Helen Rich, and an unidentified woman.

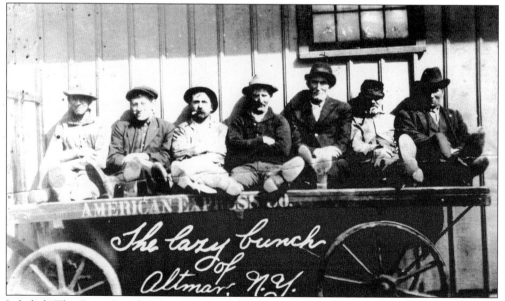

Labeled "The Crazy Bunch," these men were likely workers at Altmar's railroad depot. The tall man sitting under the window is Jim March.

Two

AMBOY

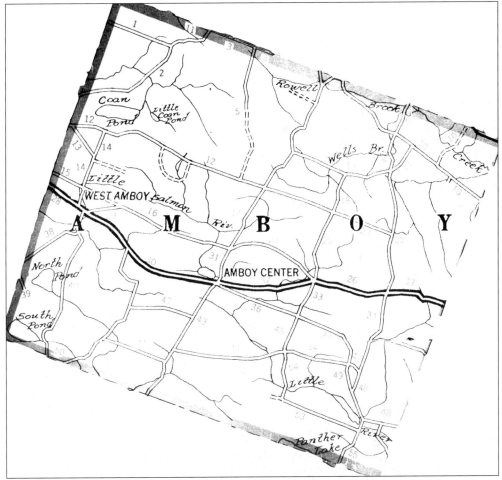

The town of Amboy was separated from Williamstown on March 25, 1830. The landscape of the town is a mix of large reforested lands, rolling hills, and rippling streams. Small ponds and lakes also dot the landscape. The early settlers were involved primarily in farming. Hops were raised in the northern section. Throughout the years, the hamlets of Amboy Center, West Amboy, Cartersville, and Jamieson Corners all had small mills and shops. The early settlers were primarily of the Methodist and Baptist faiths.

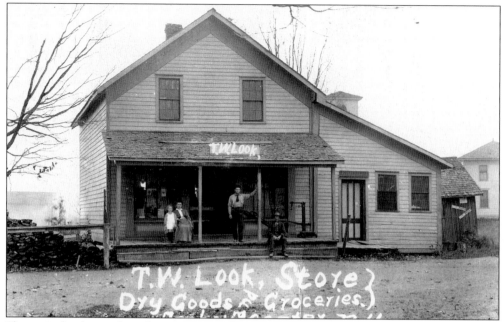

Shown is the dry goods and grocery store of T.W. Look in Amboy Center.

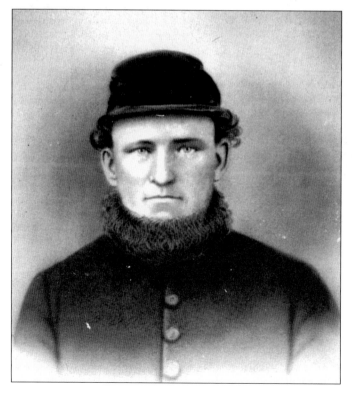

Philander Matteson poses in his Civil War uniform c. 1865. He enlisted in Adams, New York, on August 19, 1864, at the age of 39. He mustered in as a private in Company C on September 7, 1864. After being wounded in action near Petersburg, Virginia, on April 2, 1865, he was taken to Slough Hospital in Alexandria, Virginia. His leg was amputated on May 10, 1865, and he was discharged on July 6, 1865. He died in West Amboy on January 3, 1890.

20

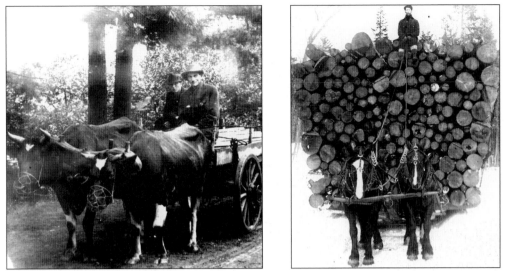

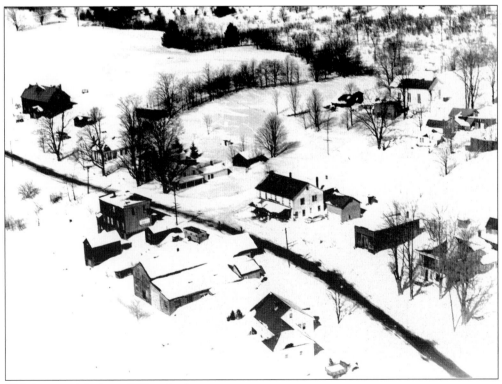

With his team of oxen, Will Meyers (left) hauls a load along Panther Lake Road *c.* 1900. Frank Parker is with him. The teamster on the right is shown hauling a large load of logs to a sawmill in Amboy. Lumbering continues to be important to the residents today.

This is an aerial view of West Amboy.

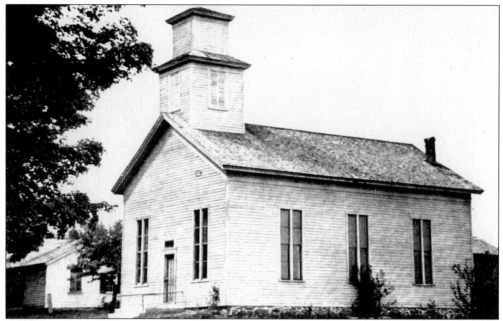

The West Amboy Church, built in 1864, belongs to the Ontario Methodist Conference. This building burned in 1976. The following year, volunteers built a new church structure.

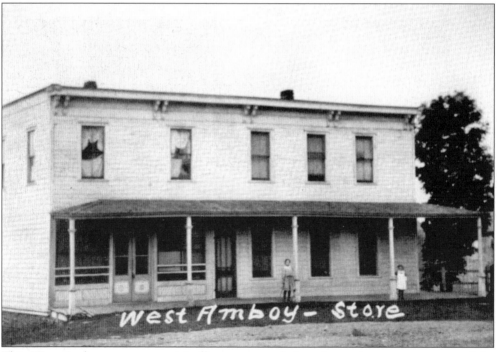

This West Amboy store was originally a stagecoach inn. Later, it was a store owned by Susannah Tripp Bulson, and even later, it became a saloon. Today, it is the home of the sixth generation of the family that first owned the building. This photograph was taken in 1910.

The Abijah Widrick family is seen at their home on Mexico Street in West Amboy. From left to right are Harriet Parish Widrick (1848–1938), Mary Crandall Widrick (1882–1920), John Widrick (1873–1963), and Abijah Widrick (1843–1922). This photograph was taken *c.* 1900.

The Amboy Center District School No. 4 was built prior to 1854. Located on county Route 23 at the top of the hill, the structure is today the home of the Amboy Historical Society and the Town of Amboy Museum. The building was donated to the historical society by Stanley and Verna (Williams) Faulkner in 1997.

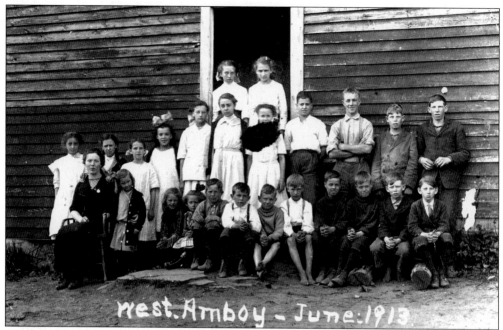

A June 1913 view shows the West Amboy District School No. 5. Teacher Myrtle Dunham Myers is in the front left.

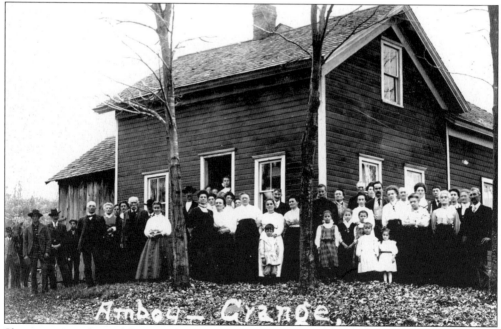

Shown are members of the Amboy Grange c. 1915. The Grange was located one mile north of Amboy Center on Route 183. The building burned c. 1919.

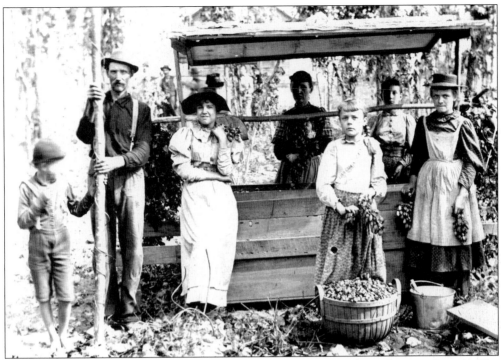

Hop picking was an important part of the early economy in northern Oswego County. The hop-picking season lasted about three weeks in the latter part of August and was an exciting social interim of the times. These early 20th-century hop pickers were at work near Happy Valley in Amboy.

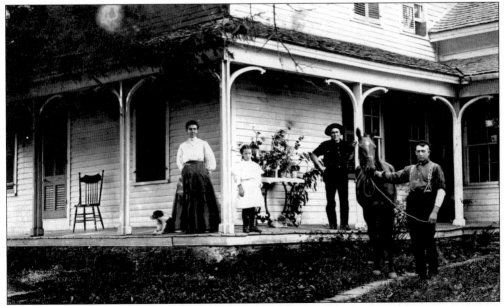

This c. 1905 photograph shows the George Foil home, on state Route 69 in West Amboy. Standing on the porch are Pearl (Seamans) Foil (Foil's wife), Gladys Foil (Foil's daughter), and George Foil. The man with the horse is unidentified.

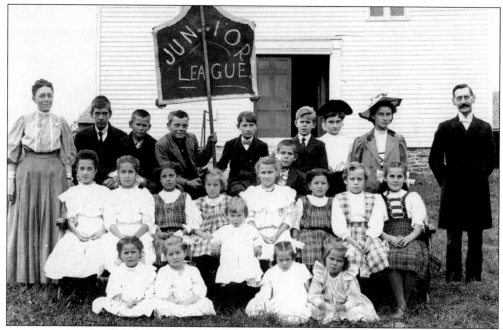

Like many small communities in the region, Amboy boasted several fraternal and religious organizations in the late 1800s and early 1900s. This photograph of the Junior League of Amboy was taken in Amboy Center in 1908.

The Stone Sawmill was located on the Fred Gherlitz farm near the pond. It operated until 1929.

Earl W. Dunn, a six-foot lumberjack, poses with a giant log *c.* 1920.

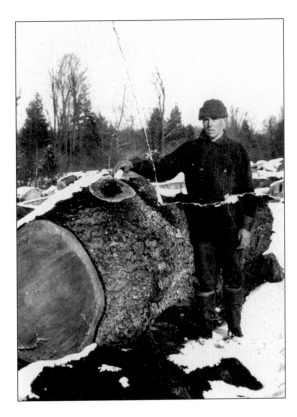

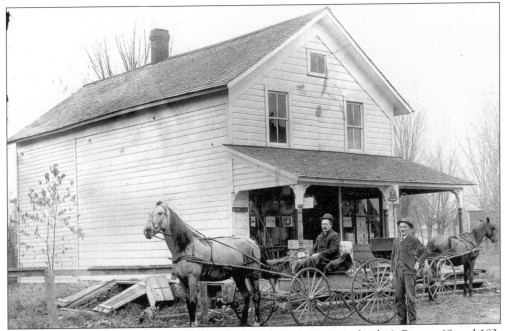

The Brown and Son grocery store was located at the intersection of today's Routes 69 and 183. This store burned *c.* 1940.

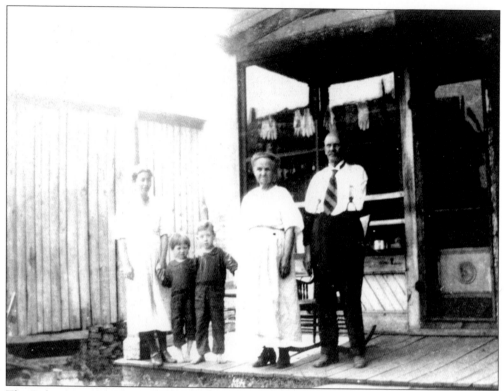

The Bulson store is shown c. 1920. From left to right are Daisy (Pettit) Bulson, Elizabeth and Raymond Bulson, Susannah "Sukie" (Tripp) Bulson, and Otis Bulson.

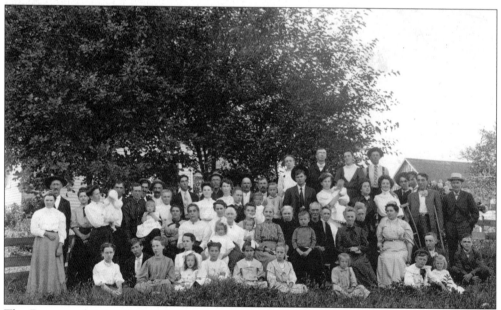

The Dunns gather in Amboy for a family reunion in 1908. Many northern Oswego County families have conducted reunions since early times.

West Amboy Volunteer Fire Department Field Days were held each year. For many years, field days were traditional fund-raising events for all small towns. Today, only a few towns still hold such events.

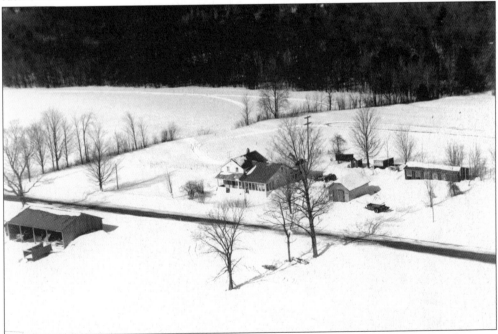

The aerial view (left) shows the Kenneth Drought farm, on state Route 69 midway between Amboy Center and West Amboy.

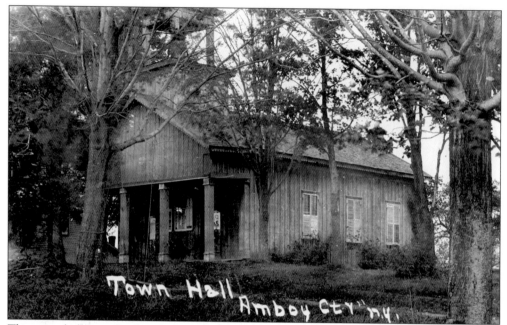

The town hall was the first framed church in Amboy. In 1824, Reverend Gillette formed a Baptist society, and he built the church prior to 1842. He left the area in that year, and the congregation slowly disappeared. This building was later assumed by the township for offices. Today, it is still used by the town.

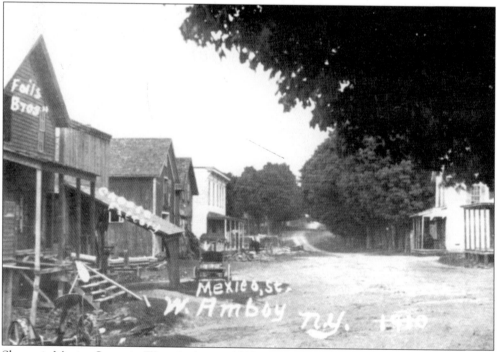

Shown is Mexico Street in West Amboy in 1910.

Three
BOYLSTON

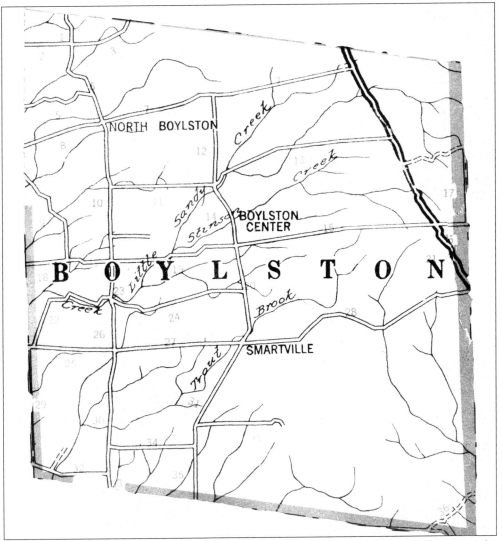

The town of Boylston was first settled by John Wart in 1812. Wart and others had come to the town from the Cherry Valley area located to the south. On February 7, 1828, the town of Boylston was separated from the town of Orwell. By this time, many prosperous farms had been cleared from the virgin forest. The settlements of East Boylston, Boylston Center, and Smartville developed around small mills and streams. The town never hosted a major industry or rail link, but for two centuries, it exported timber and dairy products. A notable cottage industry in maple syrup has spanned generations in some families, and the product is viewed by many as the tastiest in the nation.

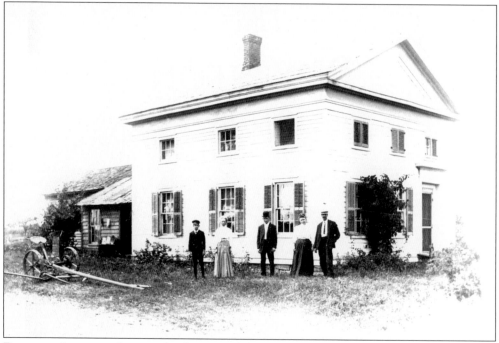

Emmerson Lester was born in this homestead, built by his father Henry Lester in 1851 on the Bremm Road. Emmerson Lester's wife was Sarah Cogswell.

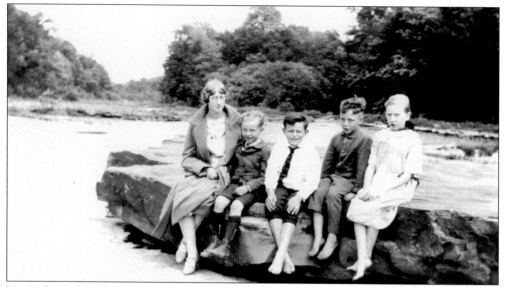

VanAuken schoolchildren and their teacher from Boylston enjoy a picnic at Salmon River Falls in June 1925. From left to right are teacher Mary Presley and students Jesse Stowell, Richard White, Harlow Chase, and Ellen Presley.

St. Joseph Roman Catholic Church served the Irish and French Catholic residents of Boylston and North Redfield from the late 1880s to 1931. The property straddled the Redfield-Boylston line.

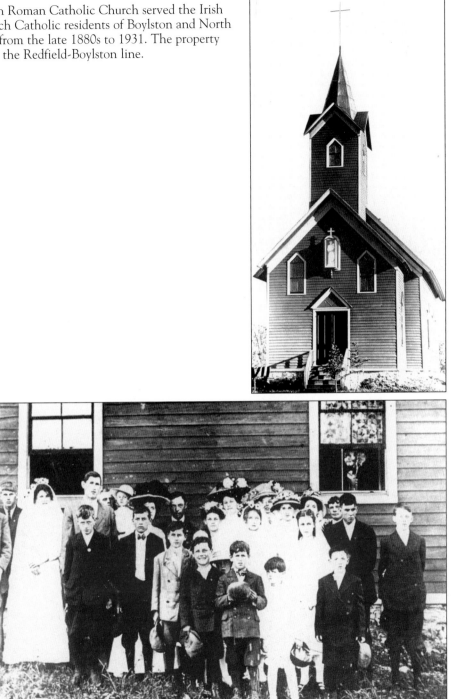

Shown is the St. Joseph Roman Catholic Church Confirmation Class of 1911. The bishop of Syracuse presided over the event. In the background is the John Brennan home, which was the original place of worship for area Catholics before the building of the church.

Pictured is Hiram W. Hayes at Lakeview Farm in 1939.

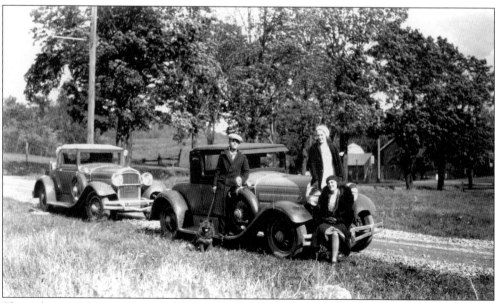

These three are Louise Howard, Adele Tyler, and Ida (Carner) Edick.

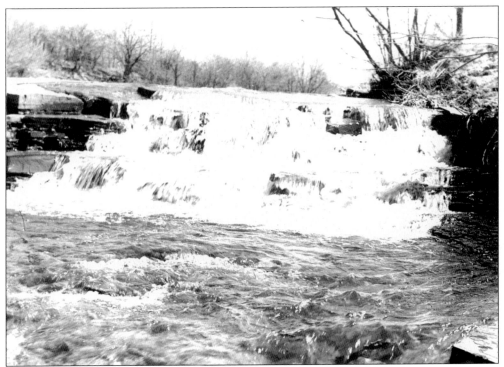

Keeney Falls is on the Little Sandy River in Boylston.

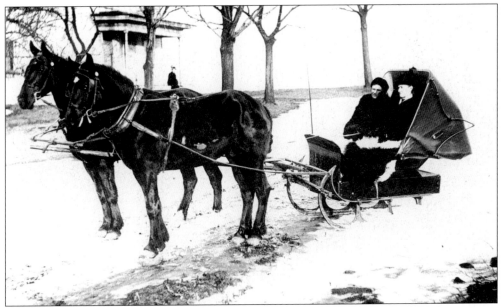

This scene is entitled "A winter's drive."

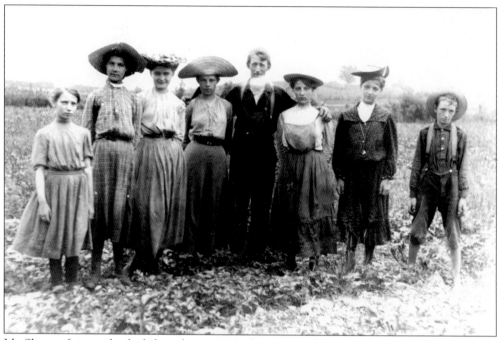

Ida Shoecraft is on the far left in this *c*. 1910 photograph of strawberry pickers in Boylston.

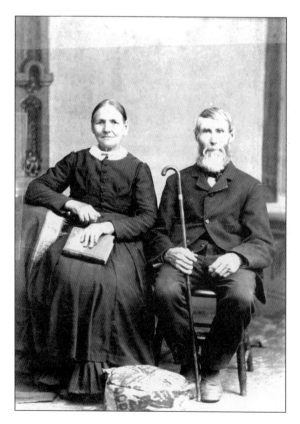

Charles Tanner was born in Surrey County, England, on May 14, 1821. He immigrated to the United States, where he met the widowed Mary Ann (Hamer) Hunt of the Herkimer County town of Wales. The couple married in 1843 and had nine children. In 1847, the Tanners moved to Boylston.

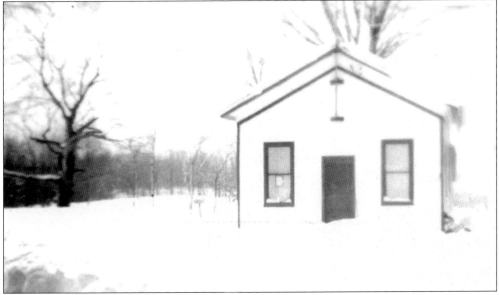

This photograph is of the Hamer-Ormsby District School No. 2.

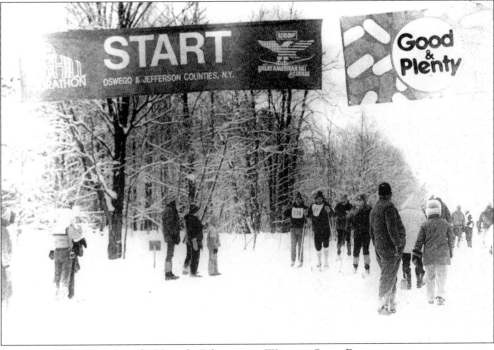

The Tug Hill Tourathon held each February at Winona State Forest attracts cross-country skiers from across the nation.

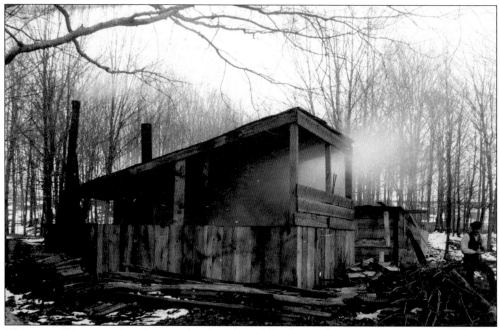

This sugar shanty is one of many that has dotted Boylston's landscape for years. Maple syrup production remains an important cottage industry in northern Oswego County. Each spring for more than 200 years, the giant maples of the region have been tapped to provide sap, which is boiled down to a fine grade of amber gold maple syrup, prized near and far.

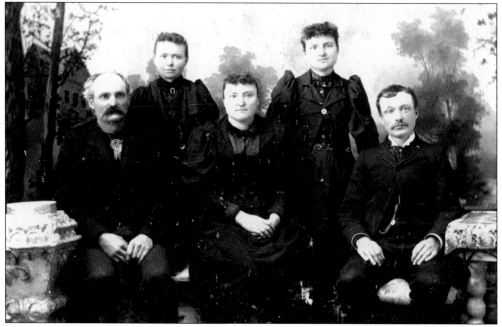

The Rev. Allen Ridgeway family had 18 children. Allen Ridgeway's first wife had nine children before she died. His second wife, Alvina, also had nine children. Ridgeway stopped preaching in 1862, bought a farm, and went back to work at his trade as a cooper. Pictured are his sons John and Michael and daughters Alzada, Annie, and Yettie

Dan Snyder was born in Boylston on May 20, 1832. He married Anna Ridgeway, daughter of Rev. Allen Ridgeway. Snyder died on November 15, 1896.

Shown is Frank Miles. Born in 1894, he died in 1971.

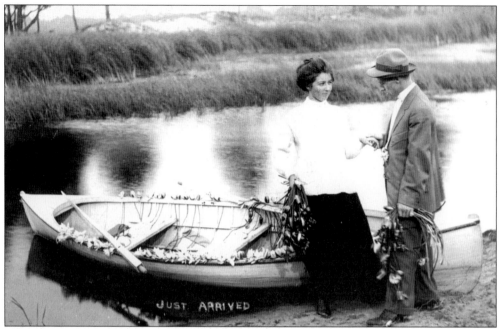

In this view labeled "Just Arrived" is Hannah (Lounsbury) Palmer and her fiancé, photographer Hobart Palmer.

Pictured are two sister-in-laws, Sarah (Winsor) Presley and Mary (Presley) Waggoner.

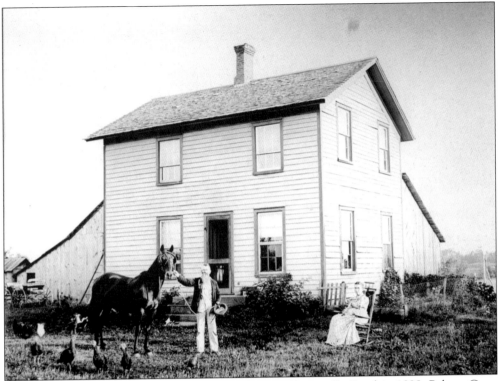

Palmer and Sarah Moore Cross pose at their farm on Smartville Road in 1898. Palmer Cross was a Civil War soldier who enlisted on December 27, 1863, in Company G, 24th Cavalry, which mustered out on July 19, 1865.

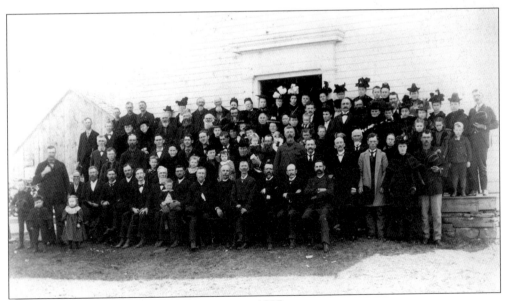

This is the Boylston Wesleyan congregation *c.* 1895.

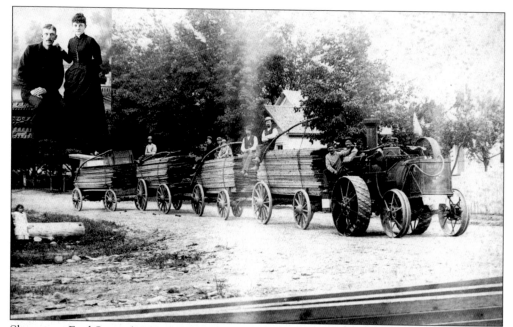

Shown are Fred Smart (1859–1936) and Cora (Hamer) Smart (1864–1946). The Smart family was an important part of early Boylston's economy. The Smarts managed an extensive logging and sawmill concern, which employed scores of residents in the mid-19th century. Following the decline of timber supplies some members of the family relocated to Lacona. The Smart steam wagon was conceived by Fred Smart and built to his specifications by the Ames Iron Works in Oswego in the 1870s. It served the Smart Lumber business for many years, transporting lumber from the mills in Smartville down to the railroad depot in Lacona.

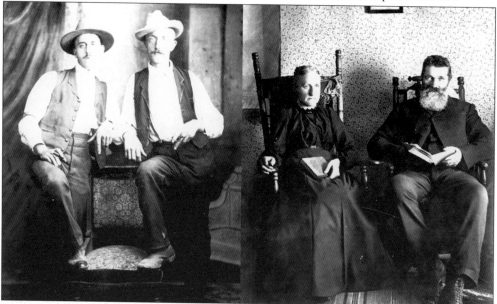

The Presleys were pioneering residents of Boylston. Art Presley and Henry Winsor William Presley (left) were brothers-in-law, and Art Presley was the son of William and Ellen (Halsey) Presley (right), who had married in 1868.

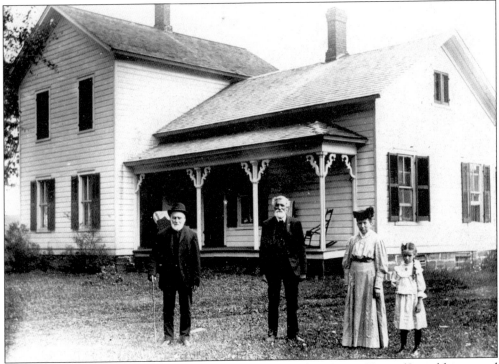

Pictured from left to right are Thomas Hunt, 83, his nephew James Hunt, 68, and his second wife, Ellen (King) Hunt, with James Hunt's granddaughter Lulu Stowell, 10.

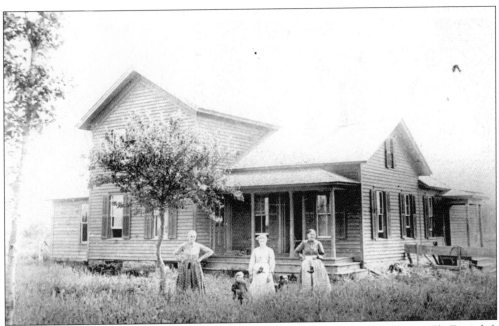

The family gathers at the Duane homestead on Old State Road (county Route 17). From left to right are Olive (Benore) Duane, Godfrey Duane, Addie Duane, and Emily (Duane) Knapp. The Duanes were among the founders of St. Joseph's Roman Catholic Church.

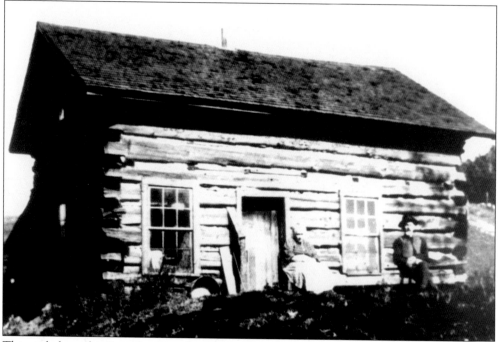

This early log cabin is said to have been one of the last ones standing in Boylston at the time of this c. 1900 photograph. Seen here are William and Clorinda Tennant. The cabin was located on property currently owned by the Edick family in East Boylston.

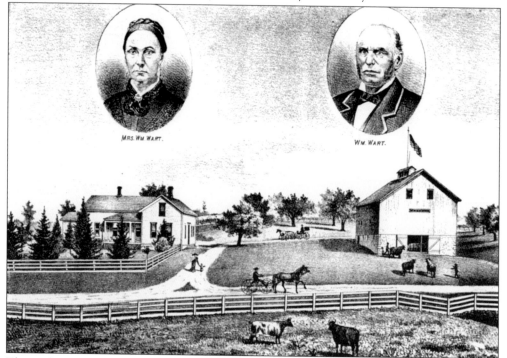

MRS. WM. WART.

WM. WART.

This is the residence of William Wart, who was born in Boylston on September 4, 1819. Wart purchased 86 acres in Boylston in 1847.

Four

ORWELL

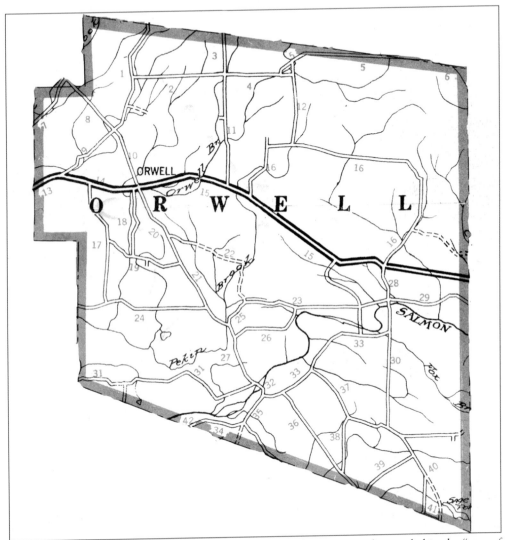

The town of Orwell was formed on February 28, 1817. The town was first settled in the "year of the eclipse," 1806. The naming of the early settlements was taken on by a young boy, Elliot Eastman, son of one of the first settlers. Eastman called the center settlement Moscow (now known as Orwell); the place down the road Pekin, after another major city; the area to the north and east Chateaugay, in honor of a French palace; and other places Vorea, Beecherville, Stillwater, and Pine Meadows. Orwell is a rolling landscape at the foot of Tug Hill plateau. Many hills in the town afford breathtaking views west of Lake Ontario and Mexico Bay. The Salmon River passes through the town in the south, and many other streams and brooks dot the landscape.

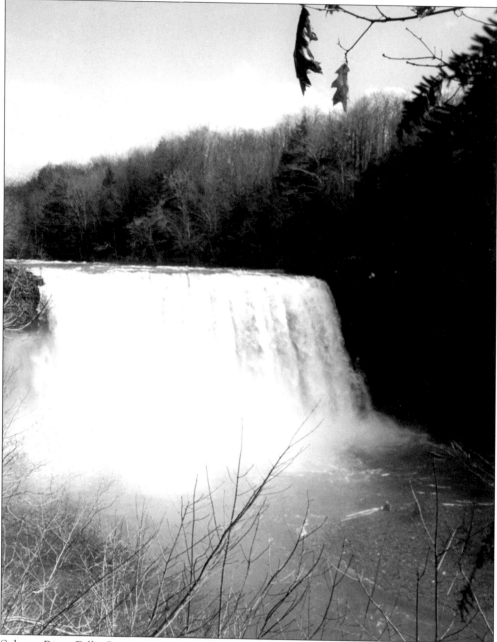

Salmon River Falls, Oswego County's "Niagara," has a 110-foot drop. Located in central Orwell township just east of the hamlet of Pekin, this treasured resource is a symbol of the beauty and power of nature. It is now owned by New York State and is just one of the many special places to be found in northern Oswego County.

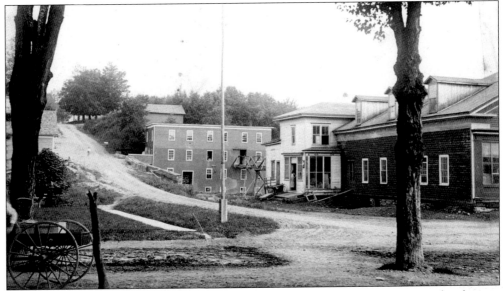

This view, looking south, shows Orwell Four Corners *c*. 1910. Orwell remains to this day one of New York State's legally dry towns, where the sale of alcohol is forbidden. The industrious citizens of the town enjoy a quiet lifestyle untainted by neon to this day.

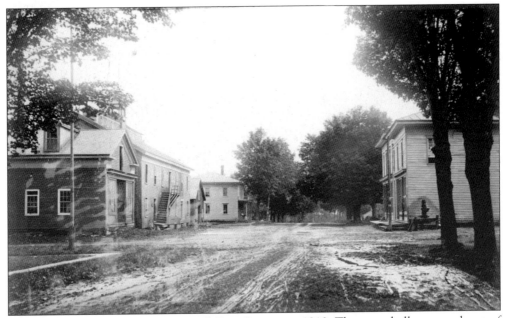

This view, looking west, shows Orwell Four Corners *c*. 1910. The town hall, a central part of the community for generations, still hosts old-fashioned dances and gatherings of citizens.

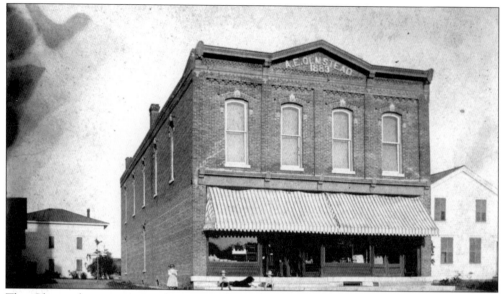

The Olmsteads were among the principal storekeepers and merchants of the town. Orimel Olmstead started the family business in 1844. This building was constructed in 1883 by A.E. Olmstead. The store operated in the hands of his descendants until 1970 and was a central part of the community for generations.

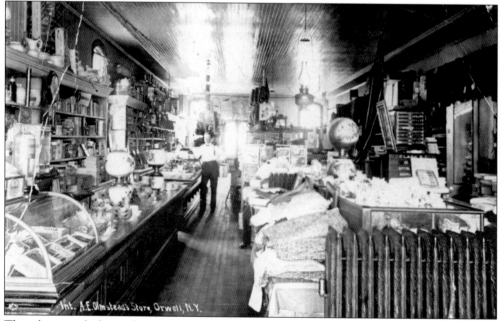

This photograph shows the inside of the Olmstead store, where items ranging from bedsprings and mattresses to groceries, dry goods, harnesses, and an assortment of farm needs were sold.

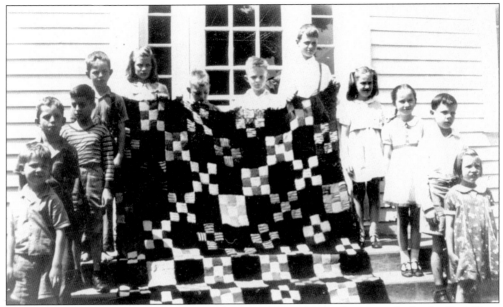

At District No. 5, the Orwell River District (Powerhouse), a quilt was made for the Red Cross to be sent overseas during World War II. Ellen Presley Wild was the teacher. Seen here are, from left to right, Neal Braley, Gene Rivers, Elmer Coyer, Joe Rivers, Bev Rowe, Derold Kaine, John Pace, Melvin Rivers, Rose Mary Braley, Frances Spink, Cedric Rowe, and Rose Marie Rowe.

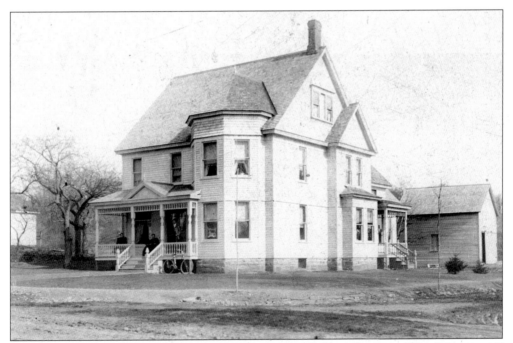

Edward Lyons built this house in 1897. He is pictured with his wife, Anna (Weed) Lyons, and his daughter, Ruby Lyons. The house was elaborately appointed and had an ornate staircase constructed of native woods. The Lyons family formerly operated a large farm in the area of Stillwater, which was flooded upon completion of the Salmon River Reservoir in 1913.

Shown is the Hunt Rowe homestead, the most prominent of the few scattered homes remaining in Pekin. No longer a full community, Pekin once had a large hotel, a store, a school, a Methodist church, and two small industries. In the late 1890s, as the settlement was in decline, the residents agitated for an extension of the Redfield and Williamstown Railroad to be built west across the flats of Pine Meadows to Pekin. One enterprising man converted a small outbuilding into a depot.

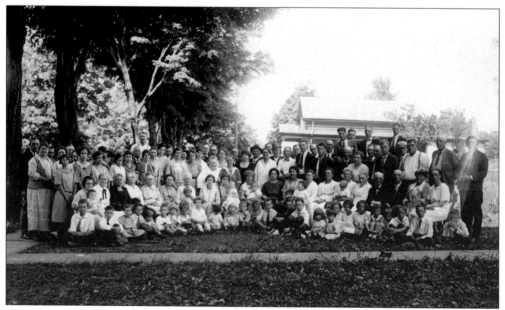

The Hiltons settled in Orwell in the early years. Shown is the Hilton family reunion held c. 1923. Among the people identified are May Warren, John Warren, Susie Warren Clemons, Herman Clemons, Susie Hilton Williams, and Dana Hilton.

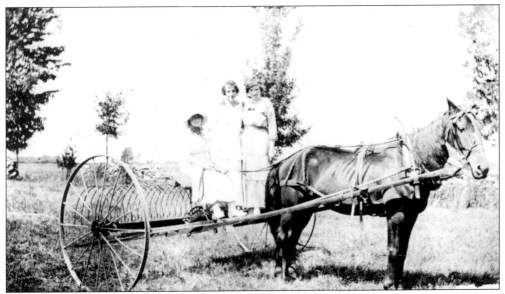

This picture is labeled "Haying in the old days." It shows the hay being raked into rows. Amelia (Barker) Hilton (center) was the first wife of Whiting Hilton. Blanche (Hilton) Archibee (right) was Whiting Hilton's sister.

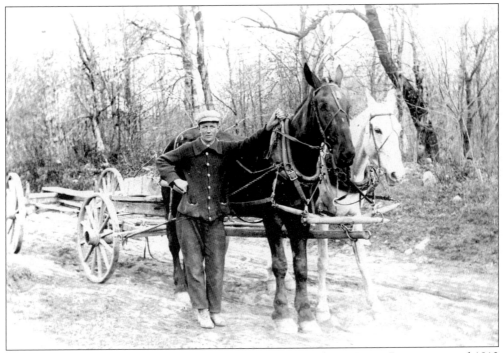

A man with a wagon and horses is pictured during the Salmon River Dam project of 1912 and 1913.

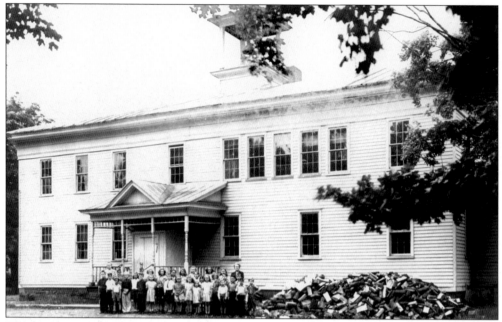

This wooden two-story Orwell Union School, shown c. 1945, was replaced with a modern one-story brick school in the mid-1950s. In the fall of 2002, the Orwell district was absorbed by Sandy Creek and the school was closed.

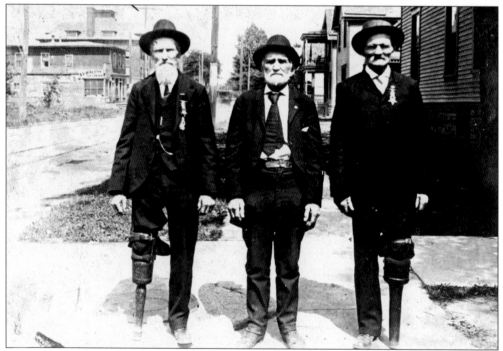

Civil War veteran Mason S. Myers lost his right leg, and his brother-in-law Robert Armstrong Sr. lost his left leg in battle. Lifelong friends, the two men wore the same sized shoe and, thus, were able to buy one pair of shoes between them. Shown with them is veteran Albert J. Potter. The photograph was taken in Syracuse in 1910.

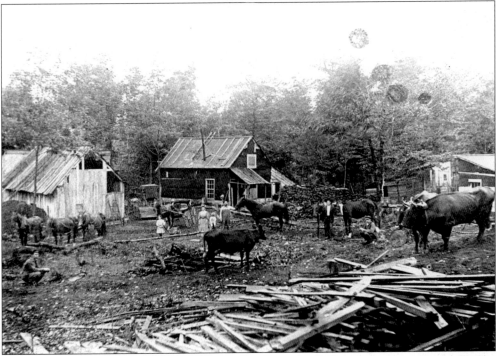

Shown are the George Carpenter house and mill in the Stillwater section of Orwell. The Carpenter family owned lands in southeastern Orwell and conducted a large logging operation there. In 1913, much of the Carpenter land was taken as part of the Salmon River power project. Other Carpenter lands on county Route 2 were later subdivided into a cluster of camp lots called Little America.

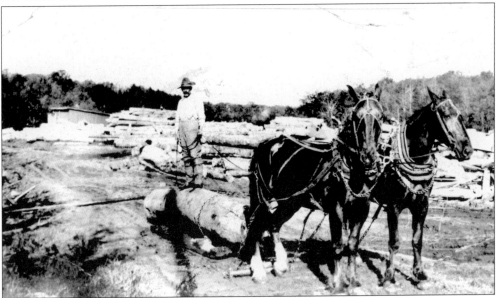

Darius Ballou (1860–1934) hauls logs during the Salmon River Dam project. Ballou's wife, Oneota (1865–1954), owned the team and was among a group of enterprising individuals who ran boardinghouses at the workers' campsites near Stillwater.

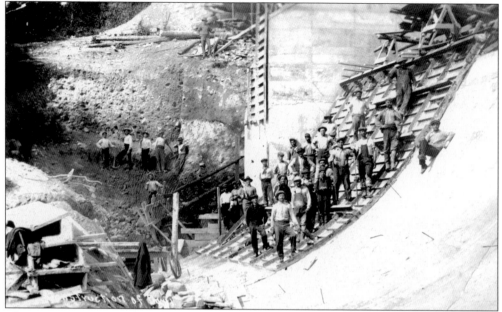

The massive 1912–1913 Salmon River Dam project was originally conceived in the 1890s as a means of sending fresh water to the city of Syracuse. In the early 1900s, however, the need for electricity proved greater, and in 1912, the Salmon River Power Company was formed from the old Oswego County Light and Power Company. The new company purchased and excavated many of the best farms and most fertile flatlands of Orwell and Redfield and removed the small hamlet of Stillwater as part of the project.

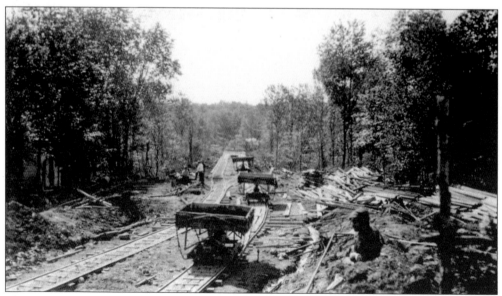

The earth excavated for the Salmon River Dam in 1913 was transported over this temporary railroad trestle. Built into bedrock, the dam was 50 feet wide at the base, 2 feet wide at the top, 615 feet long, and 27 feet high. Many Italian and Irish workers were brought into the area to move the earth and build levies on the south shore of the new reservoir.

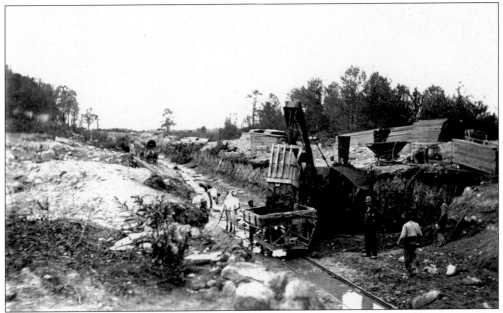

Excavation is underway for the original pipeline for the Salmon River Power Company project. The pipeline was built in 1913 to carry water two miles downhill to a power-generating plant built at Bennett's Bridges. It was constructed of wooden staves reinforced by steel bands, with an interior diameter of 12 feet. At the end of the line, a Johnson differential surge tank was built on a hill above the powerhouse.

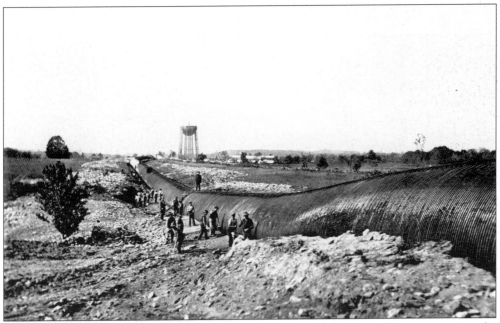

The two-mile-long wooden pipeline served the Salmon River Power Company project for nearly 70 years. As the pipeline aged, it developed thousands of leaks, which delighted the local children who on hot summer days would walk on the pipes to be cooled by the spray of pressurized water. In 1981, the old pipeline was replaced with a steel one.

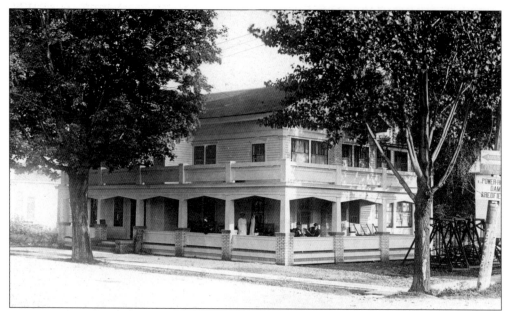

The Ideal Rest Sanitarium was opened in downtown Orwell in February 1919 by the Endicott Johnson Shoe Company of Endicott, which managed the facility. Citing the "purity of the air," the sanitarium was built as a place of rest for the "tired, weary and sick" during a time of higher rates of tuberculosis. By 1922, it had five separate buildings and had become known as a good location for those seeking a cure for lung ailments. It also served as a hospital for the surrounding area.

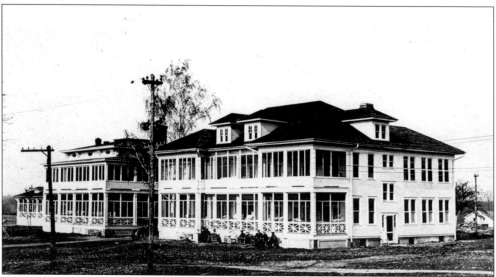

In 1910, Oswego County's leaders recognized the need to have a place set apart for the care of its tuberculosis patients. The Oswego County Tuberculosis Sanitarium was founded in 1913 on the site of the old Seymour Davis farm in Orwell. The sanitarium had an expert staff of trained professionals who treated a total of 2,080 patients between 1914 and 1927. In 1958, following the mid-century decline of tuberculosis, the county closed the sanitarium. In 1969, Fr. Raymond McVey purchased the facility. He opened it as Unity Acres, a refuge for homeless men, and founded the Catholic Relief Board to manage it.

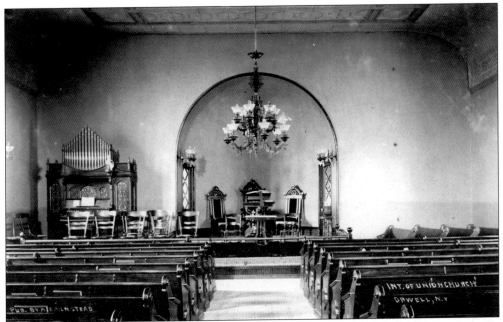

This is how the interior of Union Church looked at the time of improvements in the early 1900s. Among the improvements were the addition of two large chandeliers, which cost $135, and stained-glass windows, paid for through the fund-raising efforts of the Ladies' Aid Society.

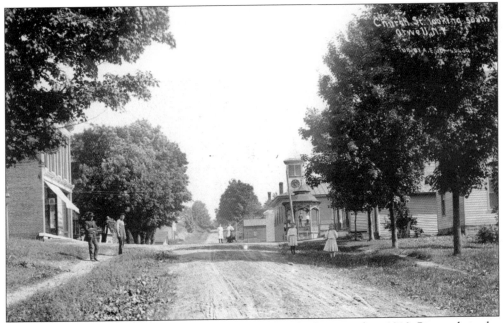

This photograph of Church Street in Orwell was taken looking north c. 1910. Pictured are the Olmstead store, the town hall, and the gazebo.

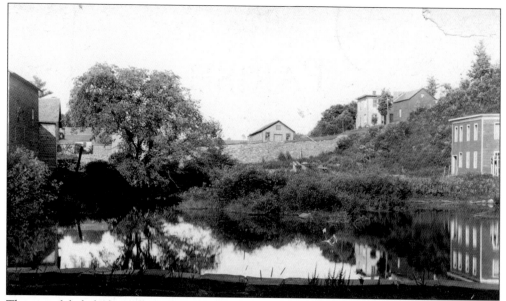

The view, labeled "the Mill Pond," was taken looking east on Mill Street from the bridge c. 1910. The rear of the Woodbury chair factory is seen.

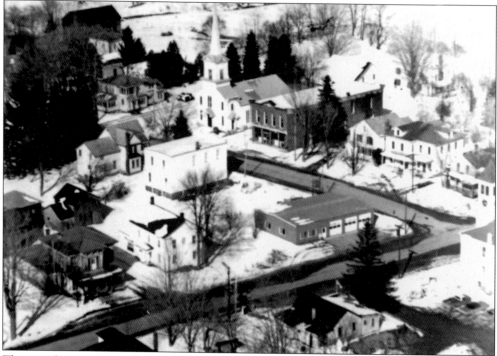

This aerial view of Orwell was taken in the 1970s.

Five

PARISH

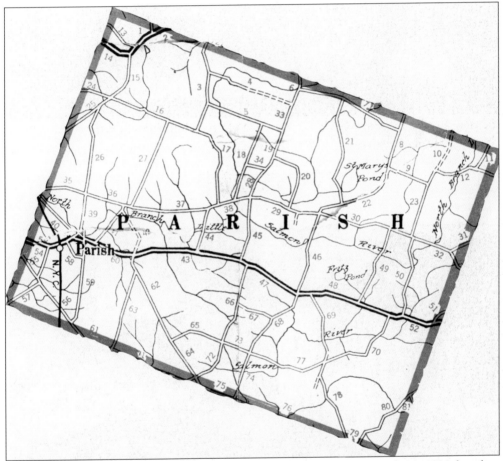

The town of Parish was first settled in 1803 and was named upon its March 20, 1828 founding for David Parish, the town's earliest landowner of note. The village of Parish, in the heart of the township, has a long history of family-run businesses. The Harters, Fullers, and Millers have each been part of the village's development. The shady streets and sturdy homes of the early residents have stood the test of time and mark the streets still with their historical appearances. Early benefactors of the town were the Mills and Petrie families, who have left a legacy of fine structures for the current generation. The town sent a large number of its sons to defend the Union during the Civil War, and notably, $9,000 was raised in bounty by the town to assist in the cause.

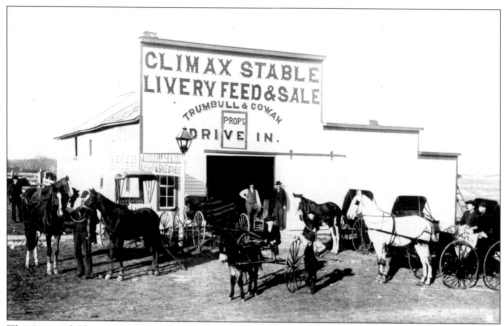

This view of Church Street in Parish shows the Climax Stable sometime between c. 1905 and 1912. The sign reads, "Livery Feed & Sale Trumbull & Cowan Proprietors."

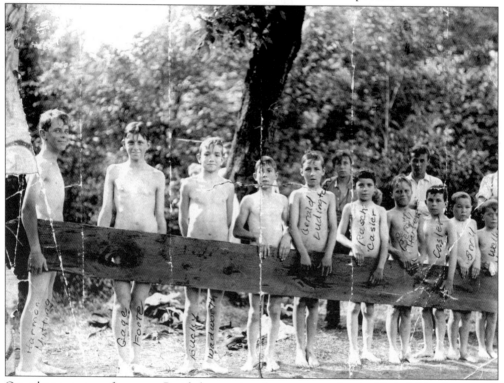

On a lazy summer afternoon, Parish boys enjoy the water at what is labeled "the Swimming Hole." From left to right are Harmon Nutting, Gage Foote, Bucky Wadworth, unidentified, Gerald Luddington, Rasch Casler, Beryl Harter, Frank Casler, ? Snell, and Wells Harter.

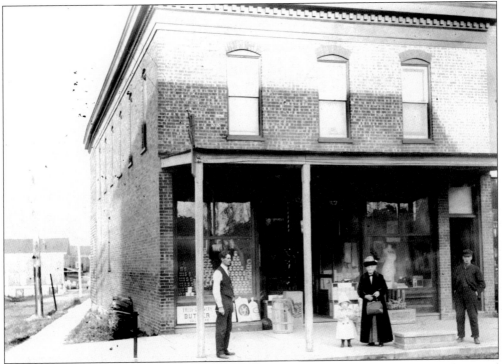

Erastus "P.D." Edick's store, on the corner of Railroad and Main Streets in Parish, was destroyed by fire in 1906. Later rebuilt, it survived for more than three quarters of a century. In 1982, when it was Fran's variety store, the building burned.

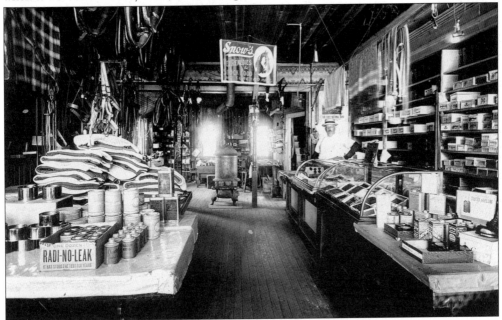

This rare interior view shows the store of Holly Hunter, in the Ellison Block in downtown Parish. The general store carried a variety of items. Elmer Ellison later succeeded Holly Hunter. The structure was destroyed by fire in March 1963.

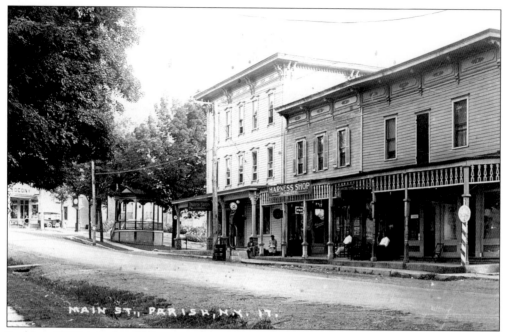

In this *c.* 1910 view, the old Commercial Hotel is prominently visible at the left of the commercial block on Main Street in Parish. Note the old bandstand on what is now Canfield Park.

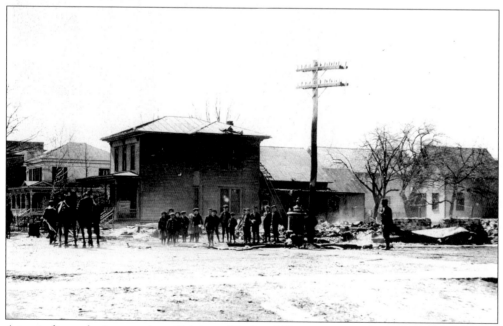

A tragic fire at the intersection of Main and Railroad Streets in 1906 destroyed the Edick store, Talcott Liquor, the post office, and Butler's store.

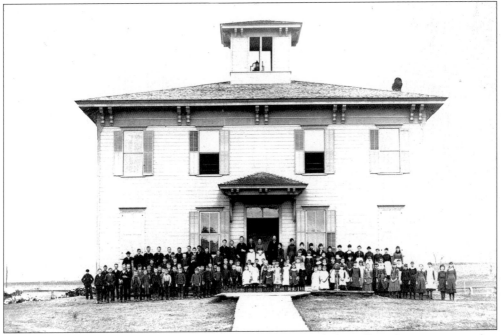

The Parish Union School was authorized in 1878. It served the village first as a union free school and after 1898 as a public high school. The classic Italianate building is pictured *c.* 1890. A new structure replaced it in 1928.

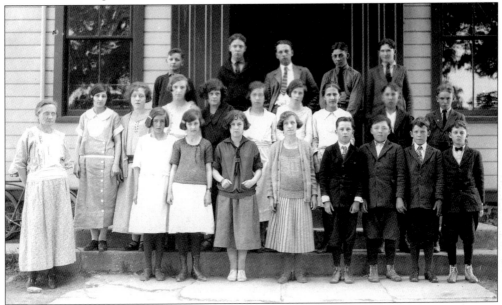

This Parish Union School picture shows the sixth, seventh, and eighth grades of 1923–1924. From left to right are the following students: (front row) Inez DeGarmo, Marion Manning, Lucy Richards, Margaret Nellis, Arden Coe, Wyat Hendrick, Charles Perlet, and Herbert Widrick; (middle row) Dorothy Baker, Leah Hawley, Vera Durgee, Arlene Johnson, Gail Durgee, Katherine Crim, Norma Alger, Lyle Halsey, and Lewis Henderson; (back row) Oren Hunter, Walice Middleton, Leo Wood, Bruce Wightman, and LeRoy French. The teacher was Mrs. Robinson.

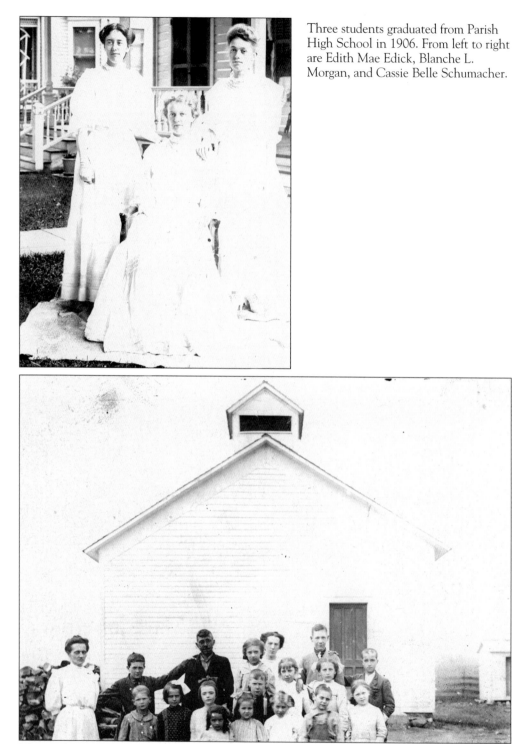

Three students graduated from Parish High School in 1906. From left to right are Edith Mae Edick, Blanche L. Morgan, and Cassie Belle Schumacher.

This is the Laing District School, on county Route 26 between county Route 22 and Allen Road. The teacher was Mrs. Robinson. Like many of the one-room schoolhouses, it was closed in the early 20th century as centralization took effect.

Women of Rebekahs lodge pose for a photograph in the mid-20th century. From left to right are the following: (front row) Neva Phillips, Minnie Niles, Alice Henderson, and Doris Dillenbeck; (middle row) Ethel Slocum, Eva Weaver, Dorothy House, Bessie Harter, and Florence Fellows; (back row) Iva Murton, Viola Howard, Rhea Henderson, and Alice Rhinehardt.

A banquet was held for the cast of a 1905 play. From left to right are the following: (first row) Edith Edick, Glen Harter, Katie Morgan, Minnie Gardner, Loyal McNeal, and Miss Flint; (second row) Cassie Schumacher, Mary McNett, Alma Cottet, Christie Edick, Ethel Edick, unidentified, and Gert Spencer; (third row) Elmer Cottet, Rev. Evan Jones, Roy Scranton, P.D. Edick, Herbert Spencer, James Owen, Earl Church, and Floyd Millard; (fourth row) Ethel Lum, Blanche Morgan, Edna Edick, Jean David, Hazel Gray, May Lum, and unidentified.

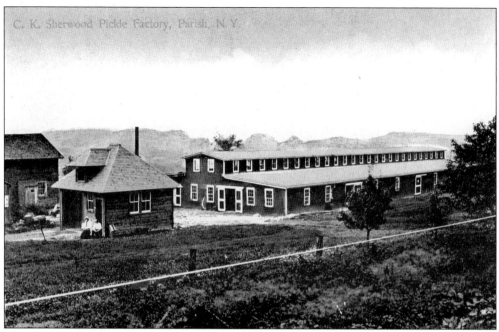

The Sherwood pickle factory was located on Dill Pickle Alley in Parish.

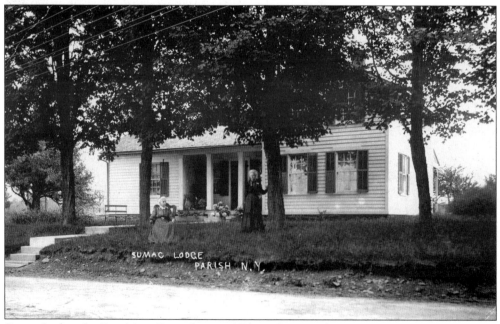

Sumac Lodge, the East Main Street home of Edwin Crim, is shown *c*. 1910.

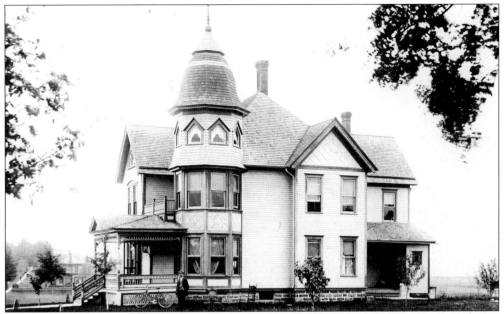

The Erastus "P.D." Edick home is located on Main Street.. The Queen Anne–style house is still a landmark in Parish.

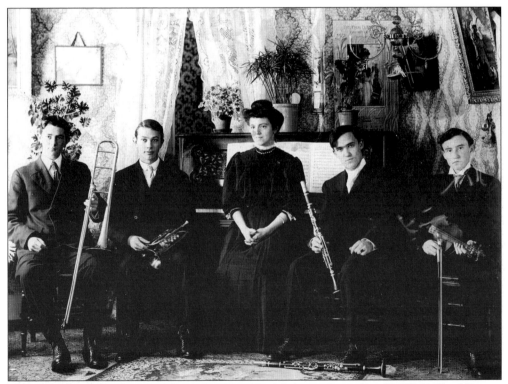

This is the Parish Orchestra of the early 1900s. From left to right are Bert DeWolf, Floyd Davey, Ethel Edick, William Wightman, and Earl Church.

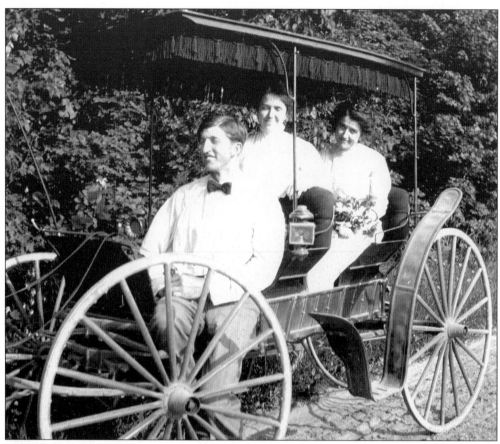

Steve (left), Mayme (center), and Ada Kieffer are out for a Sunday drive *c.* 1900.

At their home, on West Main Street in Parish, Septimus (left) and Atlanta House (right) entertain guests.

Grace Mosher (Harter) (second from the left) gives a wedding shower at the Mosher home on West Main Street.

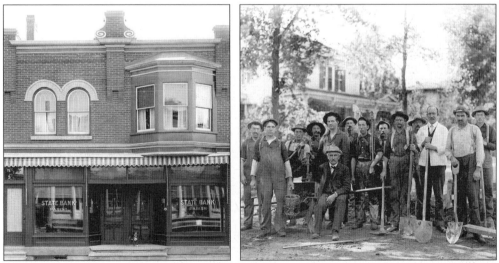

Shown on the left is the State Bank of Parish, opened by Hadwin Fuller on July 1, 1919. This building was destroyed by fire on November 29, 1922, and was rebuilt in 1924. On the right is a work crew installing acetylene gas lines in the village of Parish in 1905.

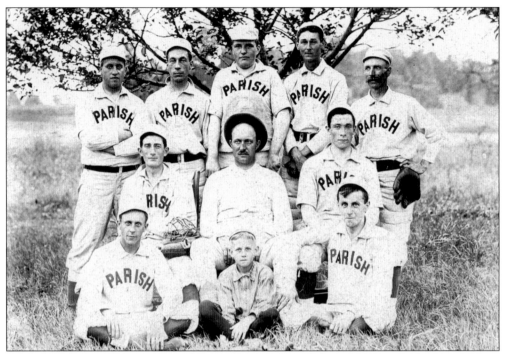

Parish has a long tradition of fine athletes. The members of this *c.* 1905 baseball team are, from left to right, as follows: (front row) Frank Carley, Donald Snell, and Bert Yorkey; (middle row) P. Fobes, T.D. Miles, and Leslie Gray; (back row) P. Miller, Tracy Gray, R. Luddington, ? Snell, and Jack Morse.

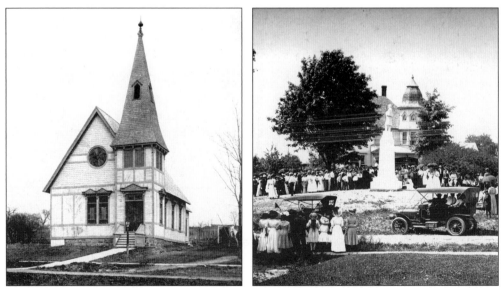

The Presbyterian church (left) is shown in the early 1900s. The *c.* 1907 monument dedication (right) is shown at Veterans' Memorial Park. The Soldiers Monument was a gift of Samuel Mills and Nathan Petrie. The Edick home is seen in the background.

Six

REDFIELD

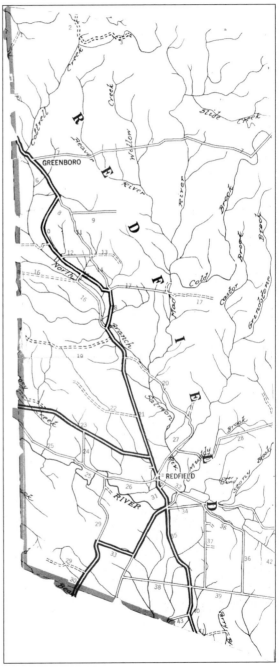

The town of Redfield was formed on March 14, 1800, but the area was surveyed and settled before 1795. Originally two townships, with the north portion independent as Greenborough from 1843 to 1848, Redfield is by acreage the largest township in Oswego County. The town was a midway point on the important Military Road, built following the War of 1812 between Sackets Harbor and Rome. In the subsequent years of peace, the road was heavily traveled by settlers coming into the area. Lumbering has been an important part of Redfield's economy since its beginning. The lands covered since 1913 by the Salmon River Reservoir were among the most productive farmlands in northern Oswego County. Farms in other parts of town relied on dairying and some sheep raising to be productive. Today, large reforested areas cover many of the old farms, and winter recreation has become an industry in Redfield, the snowiest of the townships.

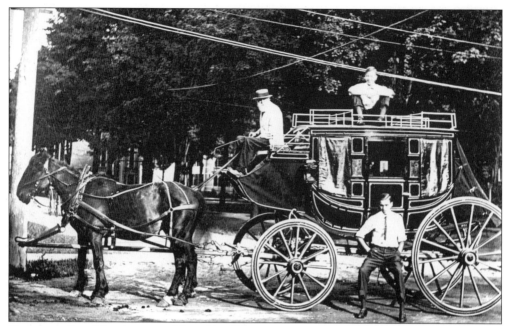

Shown are Sam Manchester and his old tallyho, or carriage. Redfield, on the main stagecoach route between Rome and Sackets Harbor, was well known for its hotels and inns. The tallyho was later retired to Kasoag Lake Park in Williamstown, where it was on display many years.

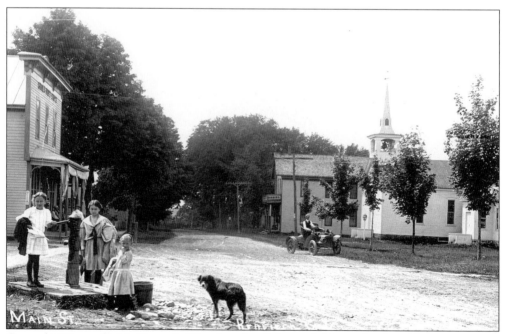

Gertrude Warren (left), Gertrude Wood, and a Balcom child stop by the old town pump in Redfield. The photograph was taken looking south on Main Street in 1910.

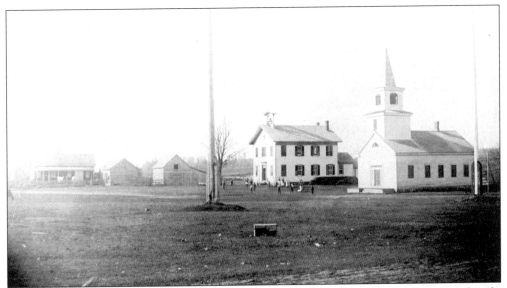

Shown are three important buildings: the old tavern, the school, and the Presbyterian church. The tavern was one of the first structures in town. The school, built in 1875 to replace an earlier one, served District No. 1. The church was built in 1829 and housed the oldest organized congregation in Oswego County. This photograph was taken after the Cleveland-Harrison national election of 1892, when the town Republican and Democratic parties each erected flagpoles on the town green.

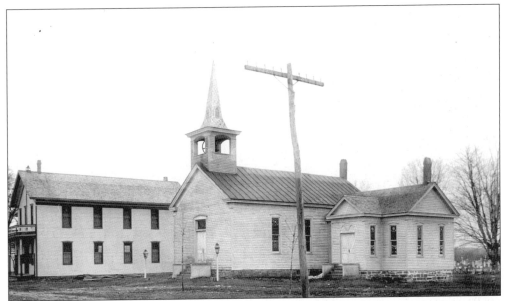

The building on the left was built as a store with town meeting hall upstairs. Long known as Bennett's Store, the structure also hosted meetings for the Odd Fellows and GAR lodges. The building on the right was constructed in 1823 and used as a Methodist Episcopal church for 100 years. In the mid-1900s, the building was sold to the Odd Fellows, who later turned it over to the Rebekah lodge. Both buildings were razed in November 2002. Myrtle Cemetery can be seen in the right background.

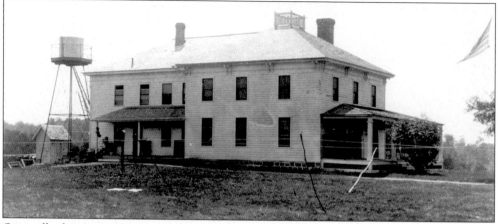

Originally the Amos Kent farm, this structure was sold to a group of sportsmen in 1911. The sportsmen called it the Oswelewgois Club, a name derived from the combination of Oswego and Lewis Counties. For many years, Niagara Mohawk executives and their guests used the club. The building is now fully restored and open to the public as Crossroads Inn bed and breakfast.

James and Sarah (Pevert) McCaw relax at home with their family on a summer afternoon c. 1922. Sarah is seated in the foreground with her son Harry. Son-in-law Clyde Hughes reclines on the porch sofa above his father-in-law, "Big Jim" McCaw. The McCaws were of Scots-Irish descent and arrived in Redfield in 1855. The Peverts were of German descent and came to the area as stonemasons.

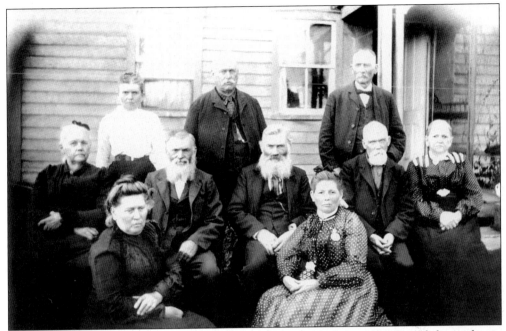

Shown are the children of Abraham and Leah (Vrooman) Yerdon c. 1890. From left to right are the following: (front row) Dolly Y. Salisbury and Mary Y. Castor; (middle row) Lany Y. Hall, Moses Yerdon, Abraham Yerdon Jr., Jeremiah Yerdon, and Rachel Y. Stevens; (back row) Nancy Y. Ward, Francis Yerdon, and Sylvester Yerdon. The Yerdon family originally settled in the Mohawk Valley and then came to St. Lawrence County in the early 1800s. Three branches of the family settled in northern Oswego County, primarily in Redfield, where they raised sheep and worked in the woods.

The Castors have long been identified with Redfield. This photograph of the family of William Wallace and Lucy (Joyner) Castor was probably taken in 1885, after the deaths—just weeks apart—of William and his son Lorenzo Castor. From left to right are the following: (front row) Minnie C. Yerdon, Lucy (Joyner) Castor, and Vernie C. Giddings; (back row) Mable C. Smith, Edwin Castor, and Jennie C. Yerdon.

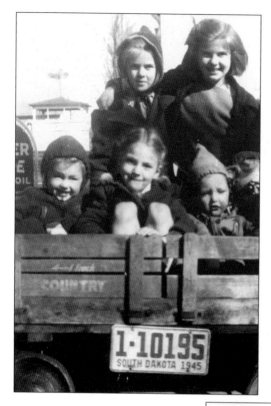

This 1945 view outside of Bennett's Store is labeled "Town kids in wagon." From left to right are the following: (front row) Suzanne Seeley, Julie Ostrander, John Seeley, and Patsy Seeley; (back row) Ella Mae Yerdon and Nancy Yerdon. Note the old town bandstand and the Episcopal church behind the children.

This school-days photograph of Doris Brown and Robert Jones was taken on the town green in 1937 as a spoof of the famed Robert Jones, who had just won a national golf title. Redfield's Jones died in a swimming accident not long after posing for this photograph. Doris Brown Allen went on to a teaching career in Oswego and served as that city's first female alderwoman. She later authored a book on her early life, which was published in 2003.

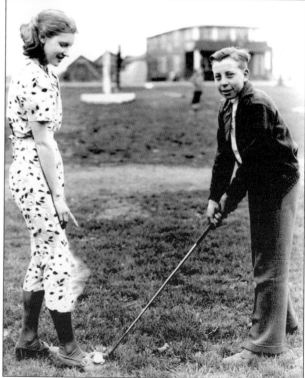

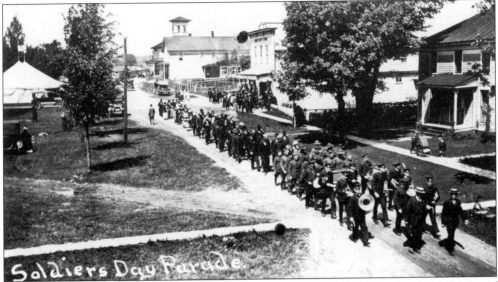

This is the 1919 Old Home Week Soldiers Day parade, featuring the returning veterans of World War I. The photograph was taken looking northeast from the old balcony above Bennett's Store . Founded in 1917, the Old Home Days celebration is still held each Labor Day weekend by the Redfield Volunteer Fire Department.

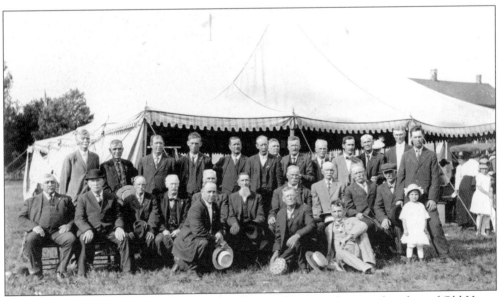

This 1919 view of Old Home Week is one of a series of group photographs taken of Old Home Day participants. The man kneeling on the left is John Wilson, the town supervisor.

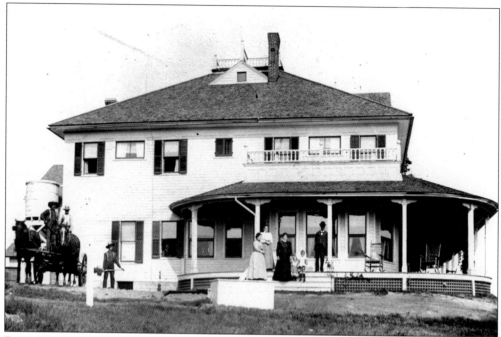

Braes Mansion was built in the 1890s by John Davidson of New Jersey. It later became the summer retreat of a manufacturing executive. The Hill family obtained the estate in the mid 1900s and used it as a residence and a restaurant. In the late 20th century, the mansion was restored as High Braes Refuge, a religious retreat.

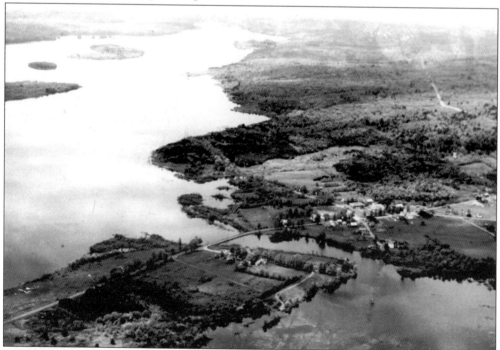

Looking northwest, this aerial view shows the hamlet of Redfield in 1945. It also shows a portion of the upper Salmon River Reservoir, which was built in 1913.

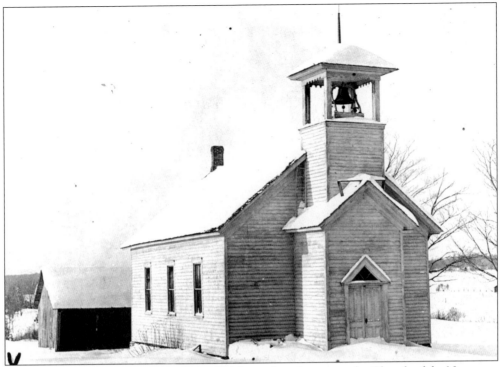

Greenboro Union Church was built in 1894. It was later known as the Church of the Nazarene. Greenboro was once a thriving logging village, with a store, hotel, school, and post office. Little trace of the settlement remains today.

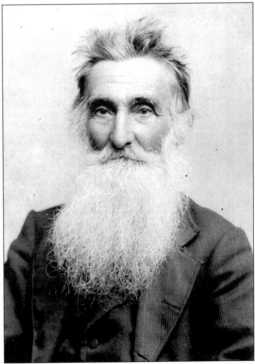

Rev. Charles Balcom (1829–1915) was a well-known evangelist from South Redfield. He was responsible for marrying, baptizing, and saving countless souls throughout the area.

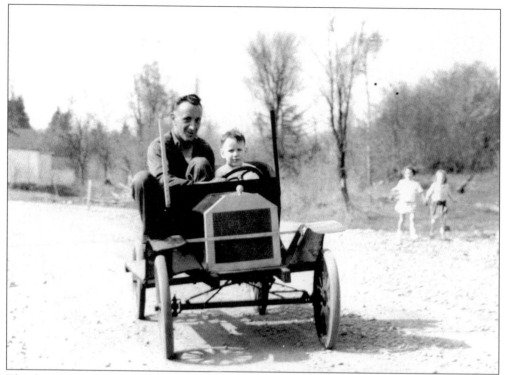

This late-1950s scene on Harvester Mill Road shows Malcolm Noble and his nephew Mike Noble riding in the minicar and cousins Connie Noble and Michelle Roche walking along the roadside.

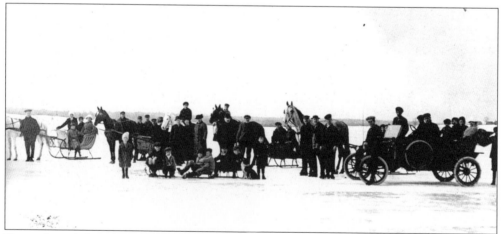

Pictured are sleds and a car on the frozen reservoir in the winter of 1915. Dean Williams owned the car, one of the first in town, bought from his brother-in-law Herm Clemons. After the reservoir was created in 1913, Redfield motorists often used the frozen expanse as a shortcut to Bennett's Bridges.

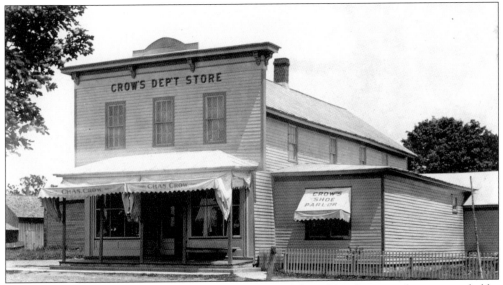

Charles Crow bought the Robert Cooper store in December 1884. Crow was later succeeded by his son Harry Crow, who operated the business until November 1954, when Clarence and Gertrude Stover purchased it. The building was razed in June 1989. During their 70 years in the store, the Crows were an integral part of the community. Family members from three generations, including Charles Crow, Harry Crow, and Harry's daughter Bethyl Crow Falvey, served as town supervisor. During the Depression, the Crow family generously carried many families over on credit, sometimes never seeing payment.

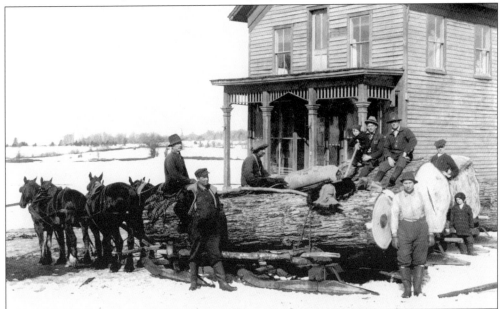

This large elm tree is seen in front of the clothing store of Sam Simpkins in 1910. From left to right are the following: (standing) Kenneth Heffron, John Clemens, and Stewart Pelton; (seated) Charles Heffron, Anslem Pappa, Sam Simpkins, Merton Heffron, William Warren, and Tom Hanrahan. The logs were drawn to Orwell on sleighs, with two teams to each sleigh. Store owner Simpkins later moved to nearby Rome, where he operated a very successful men's store.

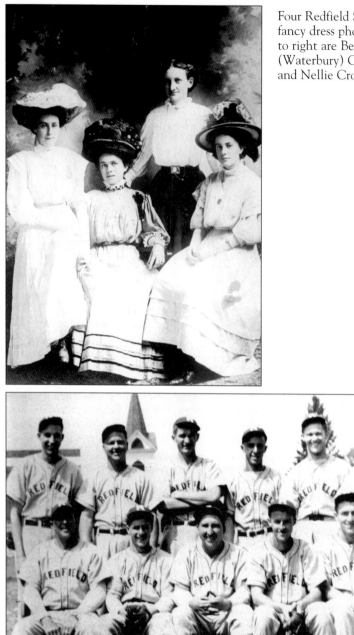

Four Redfield School friends pose for a fancy dress photograph *c.* 1908. From left to right are Bessie (McCaw) Lock, Alice (Waterbury) Crow, Catherine Jackson, and Nellie Crow.

Redfield has a long tradition of strong town baseball teams. This photograph was taken *c.* 1940. From left to right are the following: (front row) Wally Pappa, Louis Harvey, Harley Hall, unidentified, Graydon Moore, and Don Smith (O'Howe); (back row) Herm Mattison, John Lago, "Lefty" Moore, Stu Pappa, Lyman Castor, Bob Lock, and unidentified.

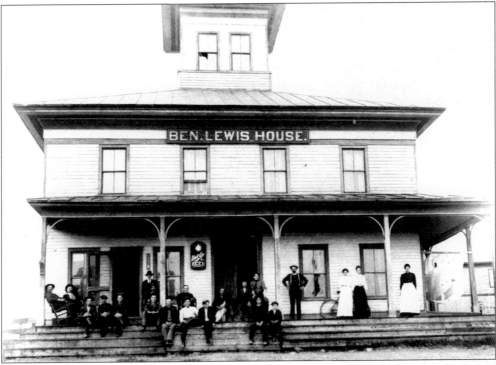

The Ben Lewis House was built by Lamont & Gardner and named for Redfield native Benjamin Lewis, who had served as a New York State assemblyman. At the time of the photograph, the Kilts family owned the business. In 1913, Charles and Theresa (Moore) Falvey purchased the establishment. The Falveys passed it on to their two sons, Stuart and Karl, and daughter, Ernestine, who operated it until selling to the Bristols in 1965. The building was destroyed by fire on October 16, 1967. Long known as Falvey's, the hotel had a barn just north of it with a good hardwood floor that was used for roller-skating and dances, which many older residents may recall.

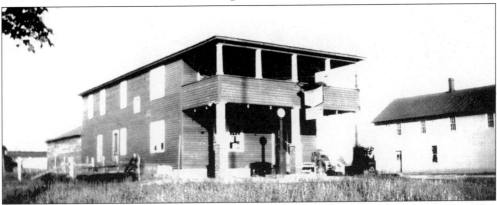

The Redfield Hotel was built on the site of the old Clemons store, which had burned in 1924. The hotel was opened by Allen and Josie (Crow) Perry in the late 1920s. After Prohibition ended, the hotels in town all did a large bar business, augmenting their fine meals. Sold by the Perrys in 1948, the Redfield went through a succession of owners, most notably Frank and "Sookie" Adams, who operated the it for more than 30 years until its sale in 2002 to the Hadcock family. This early photograph shows the structure shortly after being built. Note the old gas pump in front.

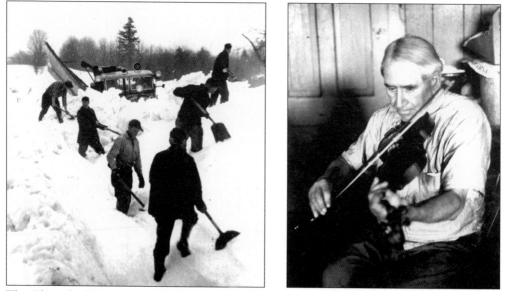

The Blizzard of March 1947, left, was one of the severest storms of modern times to strike northern Oswego County. The Redfield town road crew is shown with a Walter plow on McCaw Road. Born and raised in North Redfield, Henry Castor (1906–1985), right, was a diamond in the rough, a self-taught musical prodigy with the fiddle. He lived a simple existence, working just enough to get by. No electric wires ever interfered with his view of his farm. The bulk of his time was spent in pursuit leisure and the music that he loved. He could play hundreds of tunes from the popular to the arcane. He composed hundreds more and never wrote them down. An unspoiled natural fiddler never corrupted by the outside world, Castor was a friend and entertainer to those fortunate to know him in his little corner of Tug Hill.

After a logging job, Nelson Clifford (far left) and his companions pause outside Clifford's Cottrel Hotel, in Greenboro. The famed hotel was first opened as an inn after the War of 1812 by David Webb. The building served the North Redfield community as a store, post office, and gathering place for more than 100 years. In 1940, the land was sold to New York State and the grand old inn was taken down.

Seven

RICHLAND

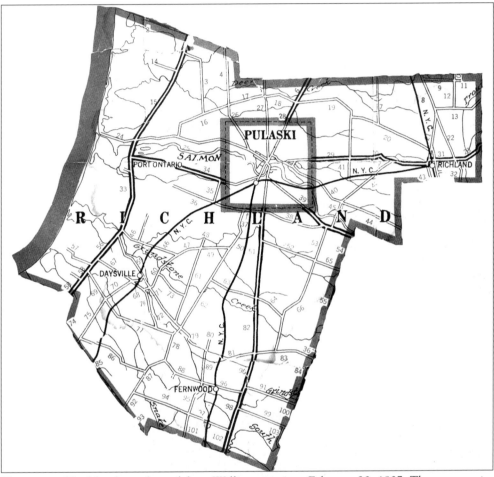

The town of Richland was formed from Williamstown on February 20, 1807. The community originated in 1801, when a handful of hardy settlers built cabins near the mouth of the Salmon River. The Salmon River hamlets of Selkirk and Bethel Corners and the once planned "city" of Port Ontario surround Selkirk Bay, where the river enters Lake Ontario. Two miles farther upstream lies the picturesque village of Pulaski. Incorporated in 1832, Pulaski is the co-county seat—its proud residents having been the first to erect a courthouse, in 1819. The Salmon River dissects the village, the heart of which was constructed of quality brick following a disastrous 1881 fire. Surrounding the business section are numerous fine examples of 19th-century architecture. The hamlet of Richland was the busy junction of two railroad lines. It boasted a hearty manufacturing economy until the decline of the railroad. Richland sits atop a portion of the Tug Hill aquifer, the waters of which supply the township. The hamlets of Fernwood and Daysville, along with numerous school-district neighborhoods, all contributed to the township's development.

The early Port Ontario bridges were constructed as toll bridges over the Salmon River, replacing Brown's toll ferry. They were located on Route 3, originally a military road that connected Fort Oswego with the fort at Sackets Harbor. In 2001, the bridges were rebuilt again. On the Short Bridge in Pulaski (right) is an early community marching band. As well as marching in parades, bands played regularly from a bandstand in the South Park. Note the old Randall Hotel at the bottom of the bridge.

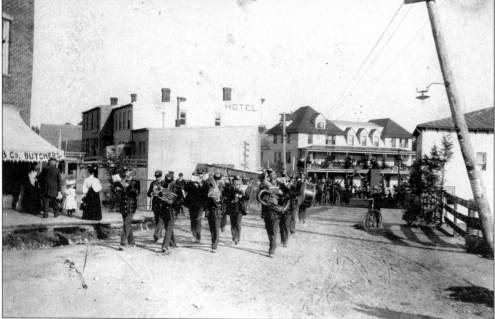

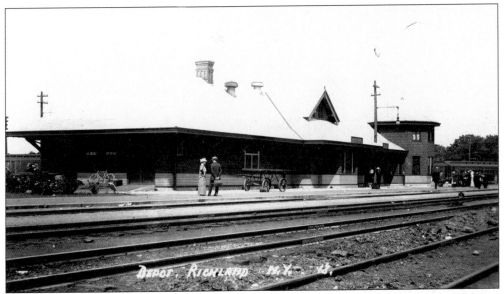

Shown is the Richland railroad station. Richland was the hub of railroad activity in Oswego County from 1900 to 1945. Served by lines originating in Oswego, Pulaski, Syracuse, Utica, Thousand Islands, and Watertown, Richland was the transfer point for passengers and freight. Inside the station, the Wright family managed a restaurant that was known throughout the New York Central system as an outstanding place to eat.

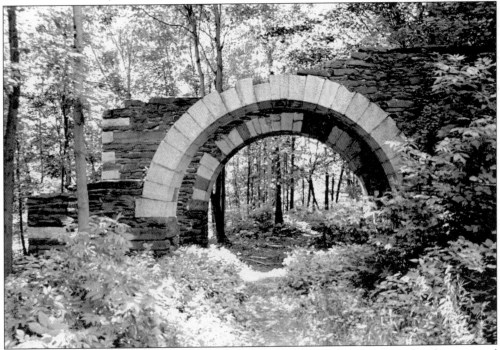

The Syracuse Northern Railroad arches were built in 1871. The early railroad connected Pulaski to Syracuse by direct rail. Spanning the Salmon River, the railroad ran northward along Broad Street near the county courthouse and out of town to Sandy Creek. The railway arches, part of a metal bridge over the Salmon River, have been described as Pulaski's "Grecian ruins."

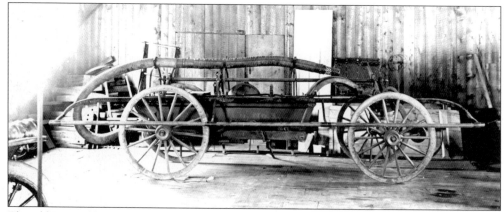

This old Ringgold Fire Company pumper was manned by up to eight people on each side. The men pumped water from the Salmon River and forced it into a small-diameter hose to put out fires.

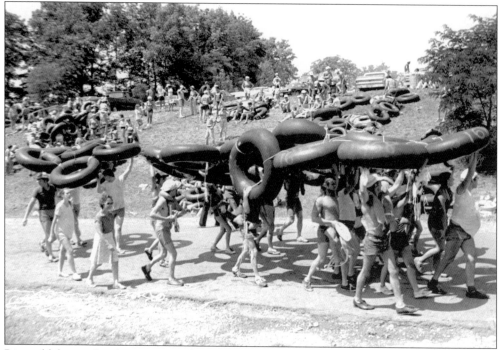

Ringgold firemen's tube races were held on the Salmon River into the 1990s by the Ringgold Fire Company to raise money to purchase firefighting equipment. The event, which drew thousands to the village, was once covered by ABC's *Wide World of Sports*.

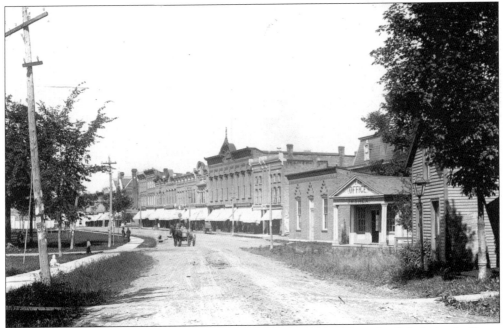

This view of Pulaski looks north from the courthouse. On the right is the Pulaski land office.

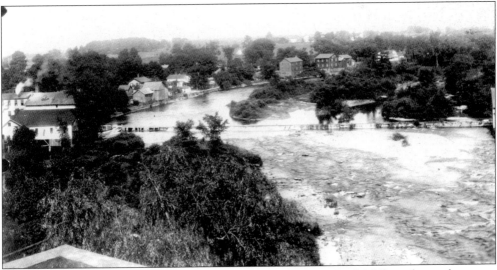

The McChesney Dam provided waterpower to the Ontario Feed Mill, a cheese factory, a sawmill, a cider mill, the Pulaski Table Factory, and Tollner's mill. Four dams in the Salmon River provided power by diverting the current to raceways on the shore to operate mills.

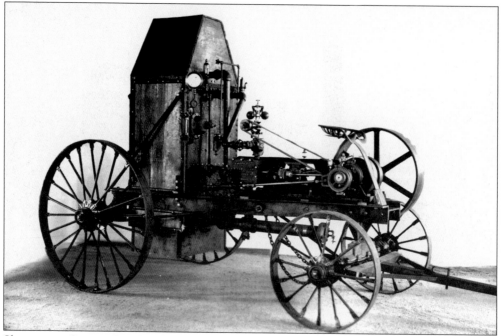

Shown is an Ontario Iron Works 1890 steam engine that was made in Pulaski. Pulled from farm to farm by horses, steam engines provided power to operate stationary farm machinery such as threshing machines.

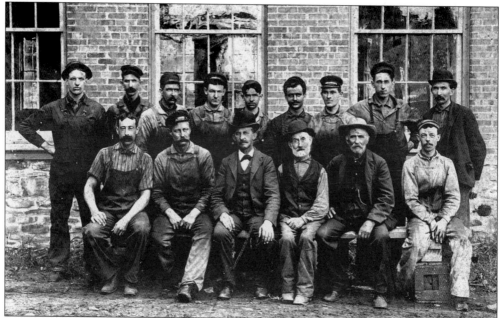

Employees of Ontario Iron Works pose for a picture in 1902. From left to right are the following: (front row) F.J. Weeks, foreman H.S. Killam, proprietor A.E. Olmstead, supervisor Benjamin Snow, Henry Filkins, and F.P. Hardy; (back row) C.L. Bonney, George E. Buck, F.A. Prouty, C.A. Sackett, Lyman Mallory, Frank Brundage, Frank Gurley, Clarence Kelsey, and G.E. Wallace.

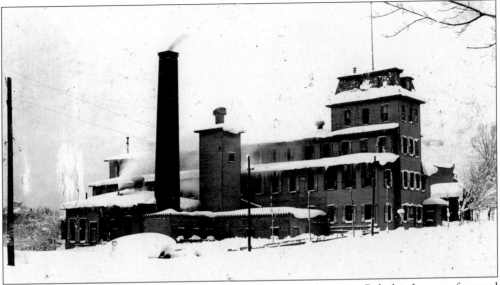

The Tollner box factory (1875–1934) was a major employer in Pulaski. It manufactured smoking pipes, home and store furniture, thread cabinets, ribbon cabinets, pencil boxes, Crokinole game boards, counter trays, and gramophone cabinets for Columbia record players. The factory was located on Mill Street, now Maple Avenue.

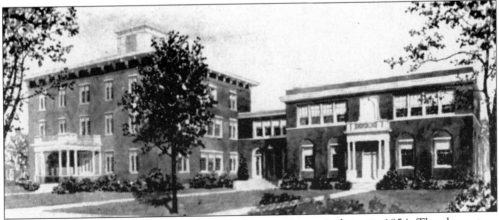

Pulaski Academy and Union School was built as a private academy in 1854. The three-story structure was enlarged in 1906 and 1926. In the late 1890s, the school became part of the town public school system. The 1854 and 1906 portions of the complex burned in a spectacular fire in December 1937.

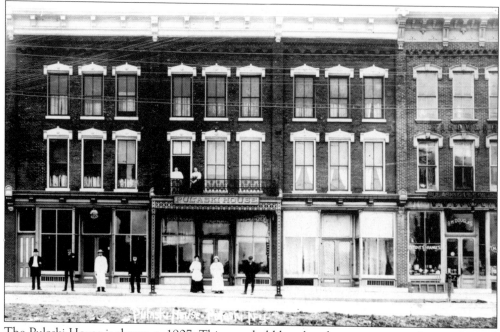

The Pulaski House is shown *c. 1907*. This grand old hotel and restaurant complex was located at the center of downtown Pulaski on the west side of North Jefferson Street. Built as part of Pulaski's reconstruction after the devastating 1881 fire, the Pulaski House itself succumbed to fire during the first General Pulaski Days, in October 1960.

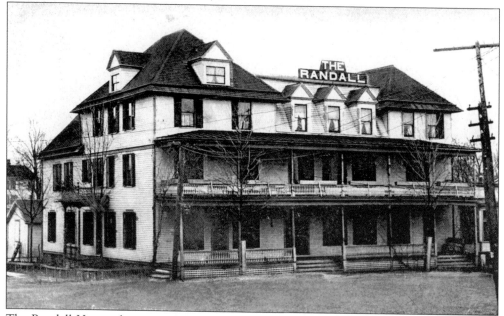

The Randall House, shown *c. 1910*, was the first tavern in Pulaski. It was built by Benjamin Winch in 1804 at the corner of Salt Road and Lewis Street. It was later reconstructed as the Mathewson House, Pulaski House, Palmer House, and later, Randall Hotel. In the late 1960s, following a fire that destroyed the third and fourth floors, the business was rebuilt as the Log Cabin Inn. That building was destroyed by fire in 2000.

The Clark-Thompson-Gasperini house was built by the Clark family, who started the Pulaski National bank. This classic Italianate building has dominated lower Lake Street for a century. It is perhaps best known as the home of Dr. and Mrs. A.B. Thompson. It is now owned by a Clark descendant.

This Victorian house was built in 1903 for Harry A. Moody and his wife of Brooklyn and Pulaski. H. Douglas Barclay, a former state senator, is the seventh generation to live on these lands, purchased by his ancestor Col. Rufus Price, a soldier in the American Revolution, in 1808. It was located on state Route 13, east of where the Douglaston manor house driveway is today. The house was torn down in 1930.

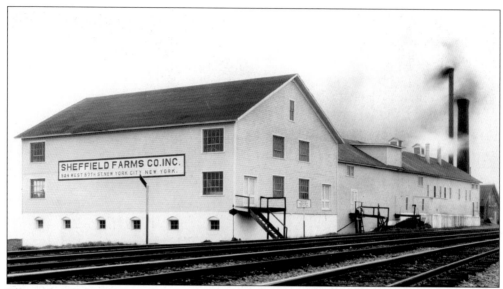

This is the Sheffield Farms Company. To market milk products, Sheffield Farms made cheese, powdered milk, and condensed milk. Originally, farmers made butter and cheese on the home farm and bartered with store owners for staples. The Sheffield Farms complex is now home to Deatons lumber.

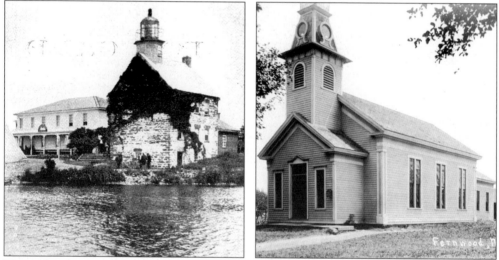

The Old Light House (left), at Selkirk Shores near Pulaski, was built to help lake schooners find the Port Ontario entrance to the Salmon River. Prior to the construction of railroads, Port Ontario was the principal way for farmers and merchants to get their products to city markets. The Methodist Episcopal church of Fernwood was organized in June 1840 and became a separate church body in 1851. This church (right) was built in 1858 at a cost of $800. The photograph was taken c. 1908. Fernwood, a sleepy little hamlet south of Pulaski, once had a school, several small businesses, a railroad depot, and a thriving mill on Grindstone Creek.

The William Peach house, on upper Lake Street, is seen decorated in patriotic finery for Independence Day. William Peach, the builder of this classic Queen Anne home, was at the time village president and a successful cheese broker.

The Richland Hotel was built to face the railroad tracks in the busy railroad hamlet of Richland. The hotel greeted weary travelers with warm coffee and home-cooked meals. The business is currently managed by Jim and Cindy Wilson and is one of the oldest continually run businesses of its kind in northeastern Oswego County.

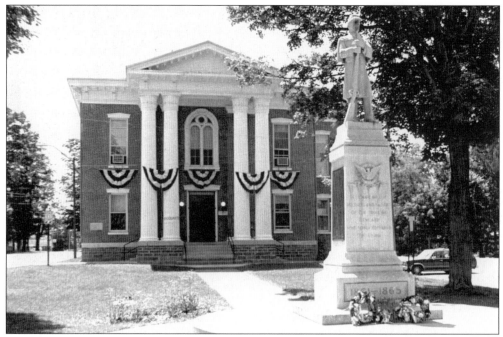

The H. Douglas Barclay Courthouse was built in 1819. It was remodeled and enlarged in 1859 and again in the late 1980s. Besides being used for trials, the courthouse has been the site of church services, lectures, concerts, basketball games, school dances, class sessions, and graduation services. Pulaski shares the county seat title with Oswego City as the result of an 1840s compromise that kept the northern Oswego County towns from seceding to form a separate county. Following its most recent last renovation, the courthouse was named in honor of H. Douglas Barclay, a former state senator. During his terms, Barclay was instrumental in convincing the state to build a fish hatchery in Albion and to restore salmon to the Salmon River.

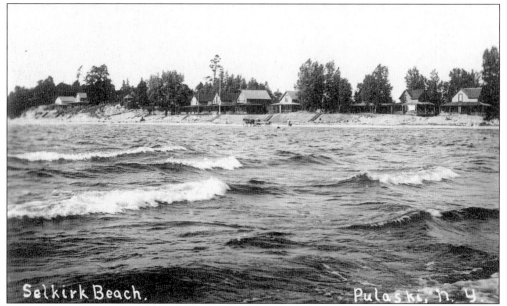

Selkirk Beach lies at the mouth of the Salmon River.

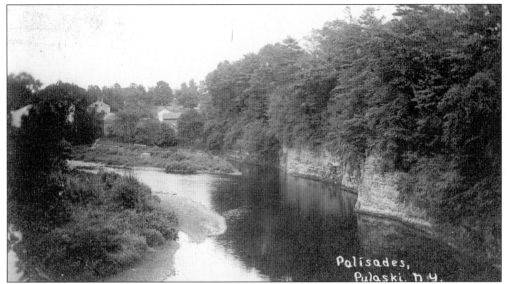

The stately Palisades guard the Salmon River in Pulaski. The river winds through these picturesque ravines on its way west to Lake Ontario.

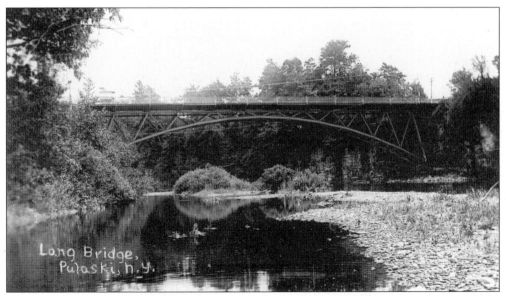

The Long Bridge crosses the Salmon River amidst the Palisades. Built in 1889, this 216-foot span was the second bridge to be built near this location. Today, a fourth bridge, constructed in 1978, spans the river.

Pulaski native John Ben Snow (1883–1973) became an executive officer of the F.W. Woolworth Company, but he never forgot his hometown. The foundation that bears his name supports many projects and organizations across northern Oswego County.

Dorothy Moody Barclay (left) and friends enjoy a day of fishing along the banks of the Salmon River.

Eight
SANDY CREEK

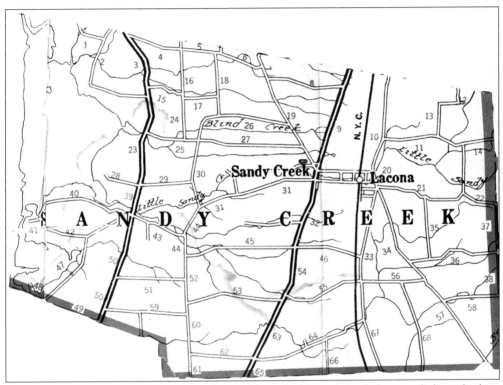

In April 1803, two men with their families and household goods loaded on ox sleds made their way along the scarcely opened State Road through Redfield and Boylston. At a point about opposite the locality he sought, one of the men, William Skinner, plunged into the pathless forest and headed for the bank of Sandy Creek, at the upper end of the present village of Lacona. The other man, Stephen Lindsay, went through Ellisburg, already sparsely settled, and finally stopped on the flat in the extreme northwest corner of the present town of Sandy Creek, about half a mile from the great pond. Other pioneers, members of the Noyes family, settled on the Ridge Road. Originally, Sandy Creek was in the town of Mexico, in the county of Oneida. It was also a part of the survey-township of Rhadamant, or No. 10, in the Boylston Tract, and was the property of the heirs of William Constable, among whom H.B. Pierrpont was the principal. By 1825, the people began to think it was more desirable to have a local name for the little settlement where the Salt Road crossed Sandy Creek. Dr. Ayer and Anson Maltby proposed the somewhat pretentious name Washingtonville. Although the inhabitants endorsed it, the name never stuck.

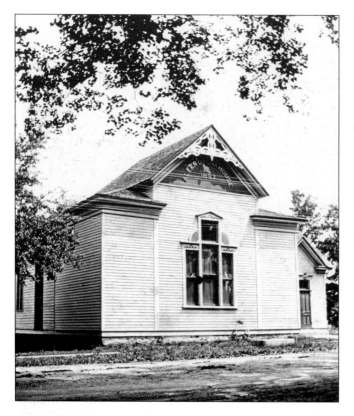

Shown is the Allen Opera House. In 1831, this building was the Methodist Episcopal church. After the church moved into other quarters across the street c. 1879, the building entered its gayest era, becoming the Allen Opera House. In 1923, it became the home of the Sandy Creek Grange. In 1960, it was razed for the construction of Interstate 81.

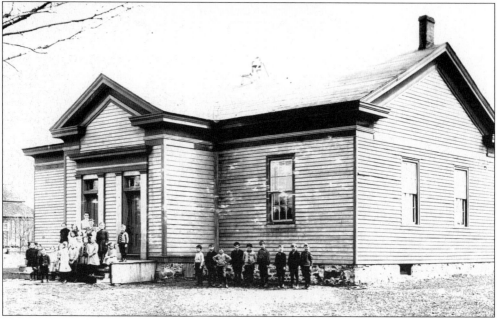

The Sandy Creek West Primary School was located on Main Street. Built in the Greek Revival style, the school served the community for many decades before being converted into a dwelling following the construction of a new school.

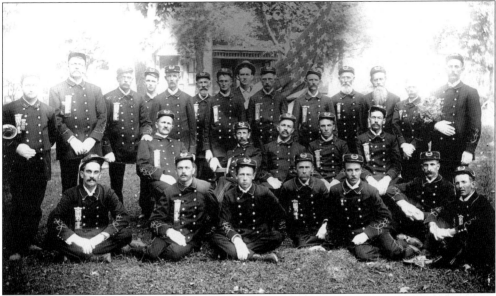

Members of the Lacona Fire Department pose for a photograph on July 29, 1898.

The Sandy Creek Fire Department is pictured in the early 20th century. Despite being twin villages, Lacona and Sandy Creek have maintained separate fire companies throughout their histories.

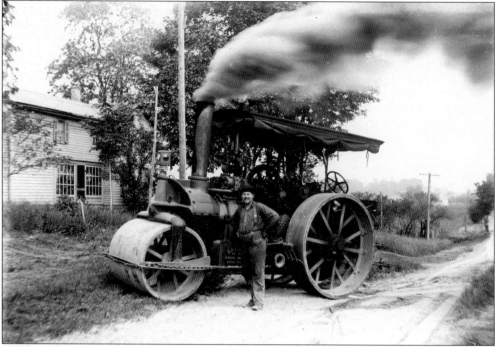

Ralph Trumbull is pictured here in front of the Simon Woodard home with one of the town's early pieces of road equipment, "the Buffalo" road roller.

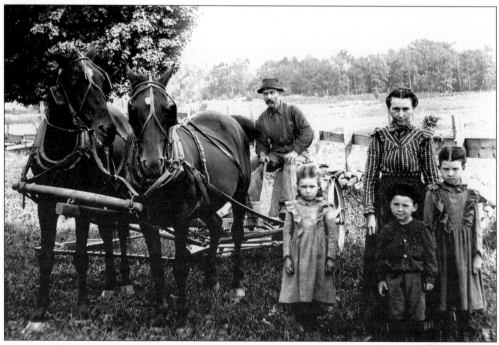

Photographer Dexter Woodard happened by the farm home of this family just as the father was headed out to the fields to cut hay with his handsome work team. The mother seems to have scrubbed three small, somewhat resistant faces and insisted on a family portrait.

This group is identified as an "Outstanding Baseball Team" on the 1912 photograph. Included in the photograph are Claus Thomas, Ivan Cole, Lloyd Sprague, Isaac Wright, Bill Carpenter, Ken Snyder, Karl Knowlton, Leland Blount, Floyd Blount, Bruce Bartlett (the bat boy), and Earl Hadley.

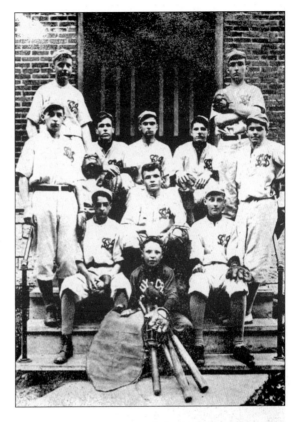

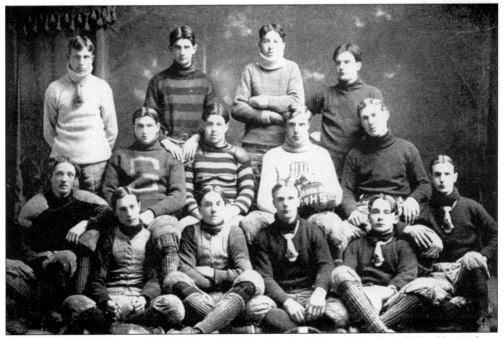

This was the Sandy Creek football team of 1903. Notice the nose guards and shoulder pads.

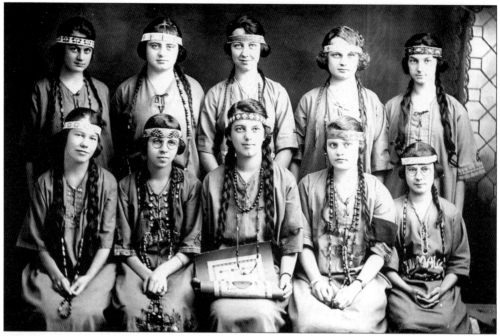

Akipsaya Campfire Girls pose for a picture in the early 20th century. From left to right are the following: (front row) Ellen Corse Potter, Mabel Carnrite, Campfire guardian Erva Landis Hyde, Gladys Archer, and Minnie Carey Bennett; (back row) Genevra Upton Knuth, Erma Cronk Bolton, Marion Bettinger Herrick, Ella Howard Pepper LaFave, and Leona Kirch Runions.

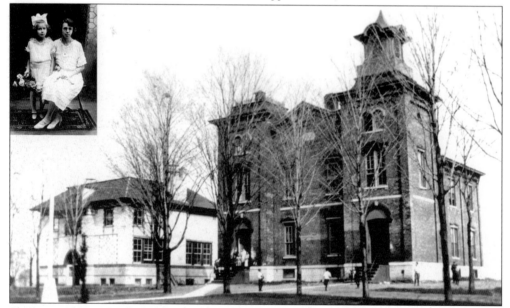

Shown c. 1920 is Sandy Creek High School. The new 1913–1914 high school is on the left. The old brick school was built in 1871–1872 with twin towers—the east one capped by the belfry. Both buildings were razed in 1929. Pictured in the inset is Mabel Carnrite, Class of 1922, and her flower girl, sister Mildred (Carnrite) Balcom, age seven, who graduated in the Class of 1933. Fresh flowers were carried on commencement night.

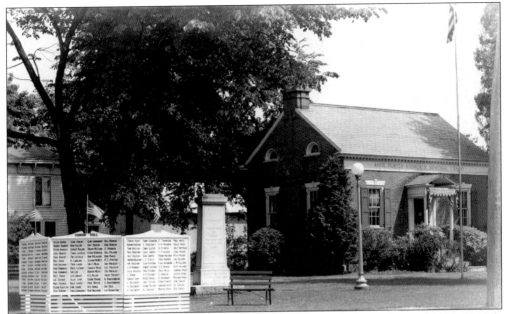

The Annie Porter Ainsworth Memorial Library was constructed in 1927–1928 in the Sandy Creek Village Park. The Colonial Revival building was a gift to the people of the town of Sandy Creek from the Honorable D.E. Ainsworth, a former New York State assemblyman who was later a state deputy commissioner of education. Ainsworth donated it in memory of his wife, Annie Porter Ainsworth. This photograph, taken *c.* 1945, shows the wooden veterans memorial and monument.

The Chamberlain-Newton House was built in 1851 in full Greek Revival style, with a pediment two-story porch. The capitals on the center columns of the porch are in the Ionic style. The entry hall has a spiral staircase and a parquet floor. The house was built *c.* 1908 for C.D. Rounds by Sandy Creek's master builder, William E. Howlett.

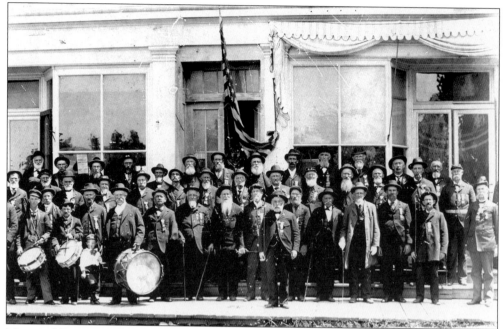

Memorial Day was called Decoration Day in the early years. This photograph shows members of the A.J. Barney post of the Grand Army of the Republic gathered in front of the entrance to their meeting rooms in the Union Block (today, the site of the village green and the Annie Porter Ainsworth Memorial Library). A poster advertising a special excursion train to the state GAR encampment is in the window of the store on the left and is dated either 1903 or 1908.

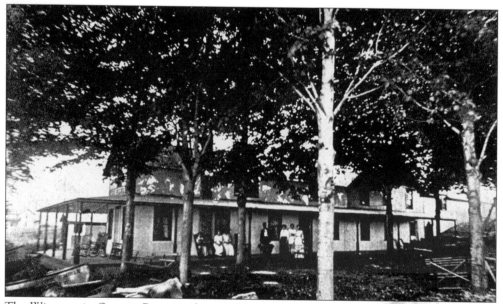

The Wigwam, in Ontario Bay, was destroyed by fire in 1947 and was rebuilt farther from the shoreline. The subsequent hotel and restaurant served the public for many years until another fire occurred in the late 1990s. Carnsie's Irish Wigwam Restaurant was rebuilt on the site.

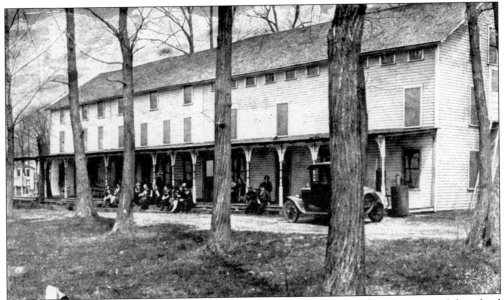

Another early-20th-century hotel well known for its pleasant accommodations and fine food was Ackermans Hotel in Sandy Pond.

The Hamer family spends a day at the beach c. 1910.

Employees of Corse Press pose for a photograph *c.* 1915.

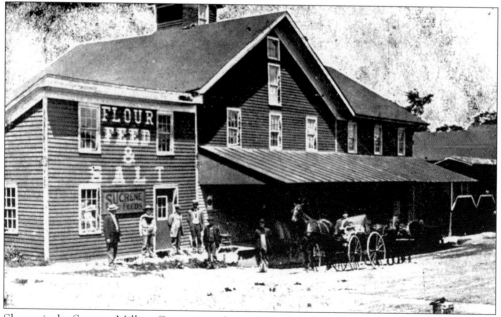

Shown is the Stevens Milling Company in Lacona. At the time, it was owned by T.W. Harding.

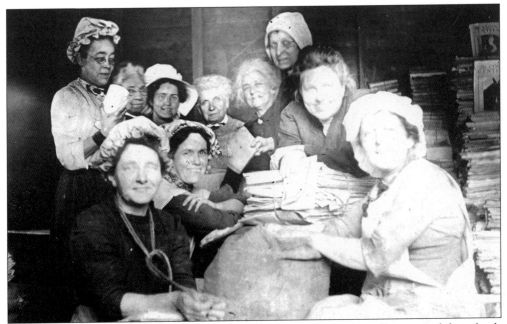

Members of the original Coterie Club sort papers and magazines to sell as part of their fundraising efforts for construction of the clock and tower. In this *c.* 1920 photograph, from left to right, are the following: Cora Smart, Mrs. Shear, Sue Gilbert, Cora Howlett, unidentified, Del Howlett Porter, Mrs. C.M. Salisbury, Ola Ackerman, and two unidentified women.

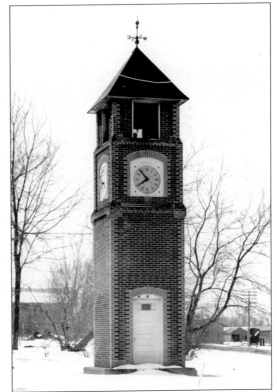

The Coterie Club donated this clock and tower to Lacona village in the early 20th century.

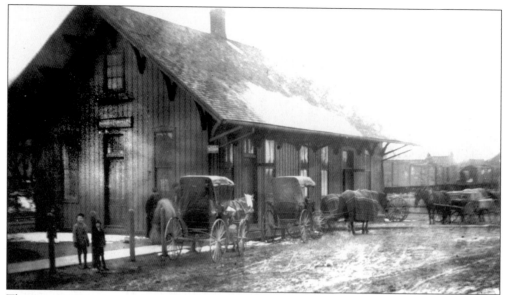

This is an 1891 view of the railroad depot in Lacona. The railroad ran through east Sandy Creek as early as 1851 and consequently the idea arose to build another village around the depot and the very convenient euphonious name of Lacona was adopted. The depot is currently being restored as municipal offices.

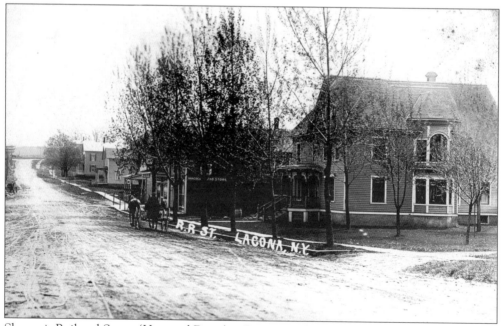

Shown is Railroad Street (Harwood Drive) in Lacona at the beginning of the 20th century.

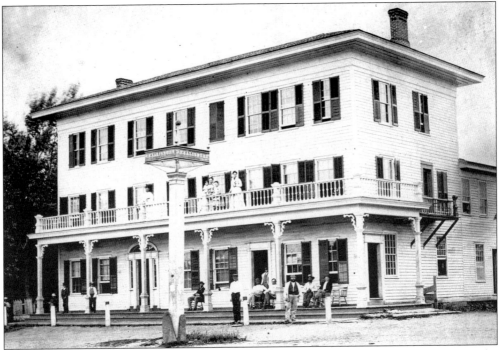

The Salisbury House was a grand old hotel and restaurant that catered to travelers along the old Salt Road (Route 11). Situated on the north bank of Little Sandy Creek in the village of Sandy Creek, the hotel entertained travelers for nearly a century before being destroyed by fire in 1884.

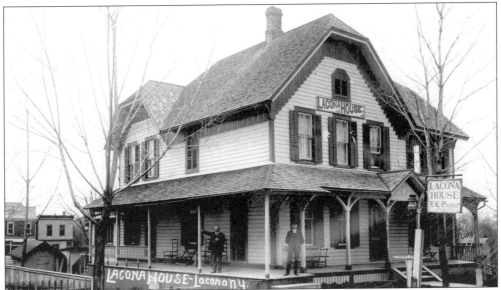

The Lacona House, on Salina Street, was the property of C. Eugene Plummer at the time of this photograph in 1914. The house was constructed between 1867 and 1877 by Nathan Davis, whose father, Frank C. Plummer, purchased the Lacona House in July 1893. It was also known locally as the Plummer Hotel and was across the street from the railroad depot for the convenience of travelers.

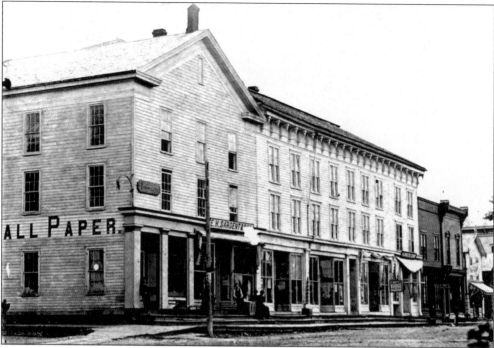

The former east side business district of Sandy Creek village consisted of the California Block (1854), Union Block (c. 1860), and the twin Colony and Cook Blocks (the 1880s). The whole district was destroyed by fire on January 9, 1912. The village green and library occupy the space today.

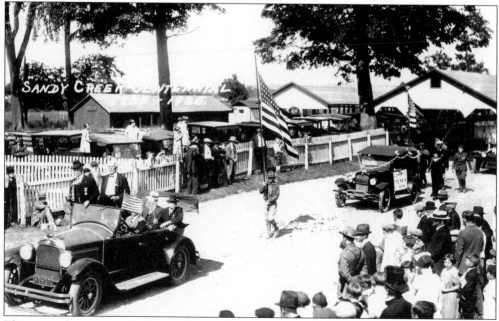

This view shows a parade for the Sandy Creek centennial (1825–1925). The town of Sandy Creek was settled in 1803 and formed from Richland in 1825. The 1925 celebration was one of great civic pride and optimism toward a prosperous future.

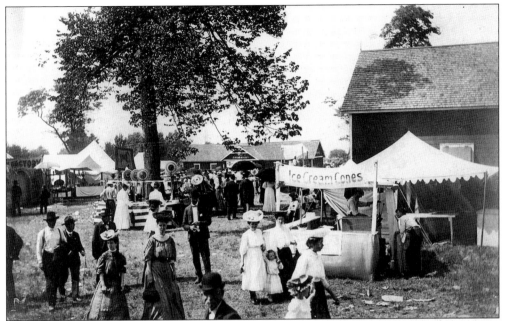

The Oswego County Fair was founded in 1858 as an annual event of the Sandy Creek, Orwell, Boylston, Richland, and Redfield Agricultural Society. Long known as "Old Sandy," the fair continues today as a county-wide event held in July. The above photograph, taken in 1909, shows the Baptist church ice-cream stand in the midst of well-dressed fairgoers. The photograph below shows a sulky ready to race at the fair on August 16, 1939.

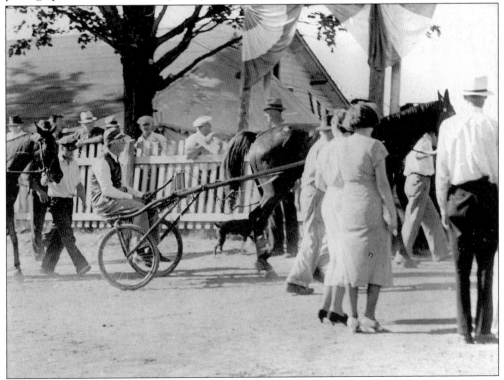

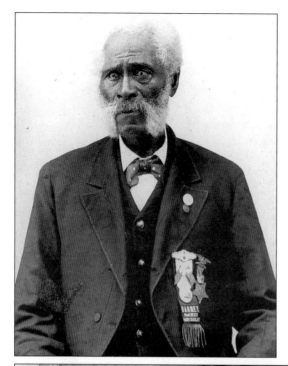

Cpl. Henry F. Roberts was born into slavery on October 1, 1815, in Hagerstown, Maryland. After gaining his freedom, Roberts served in the 29th Connecticut Volunteers during the Civil War. Following the war, he relocated to Sandy Creek, where he was a well-known and respected member of the community. He was a flag bearer of the A.J. Barney post of the Grand Army of the Republic in Sandy Creek. He died on December 28, 1909, and is buried in Sandy Creek's Woodlawn Cemetery.

This photograph, taken in October 1942, shows the Noble family of Lacona as they dine together before Rex, a son, went into service. Seen here are, from left to right, Reah Noble, Arthur Noble, Leola Remington Noble, Clarice Carr Noble, Rex Noble, Cora Carr Walker, Earl Noble, and Malcolm Noble. The family later moved to Redfield. Cora Walker had a store in downtown Lacona for many years.

Nine

WILLIAMSTOWN

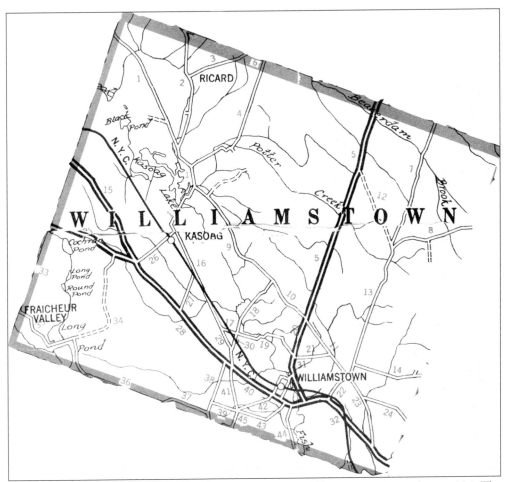

The town of Williamstown was formed while within Oneida County on March 24, 1804. The earliest settlers arrived from Connecticut c. 1801. The town is named in honor of Judge Henry Williams, who was prominent in the early years of settlement. The soils of the town are sandy loam, which is most productive for potatoes and grazing. The early settlers were augmented by a mix of Irish and French settlers drawn to the town by its lumbering industry and also the small mills that operated along the railroads that served the town. The main settlements in the town are Williamstown hamlet, Ricard, Fracheur (known as Happy Valley), Wardville, and the picturesque settlement of Kasoag along the small lake by the same name. The once busy little mill stop of Maple Hill has nearly vanished except for the hardy descendants of its early families who still live along Maple Hill Road.

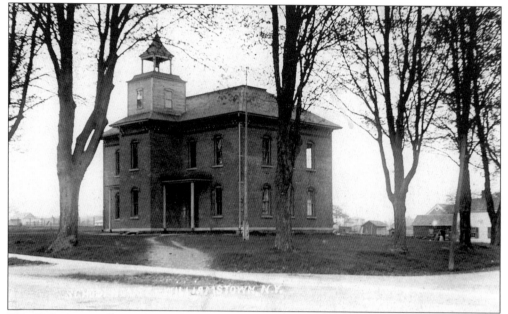

The Williamstown Union School was built in 1885 on the corner of Routes 13 and 17 North. It was closed in 1963 and torn down in the mid-1970s.

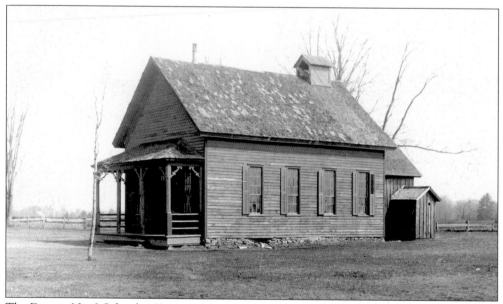

The District No. 3 School at Kasoag is shown in 1912. The school was located on county Route 30 near the Route 30A intersection.

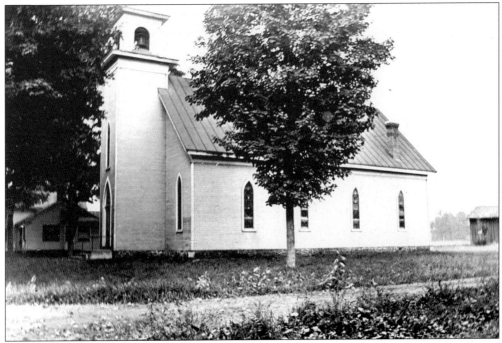

Shown in 1915 is St. Patrick's Catholic Church, located on the corner of Main Street and Cox Road in Williamstown hamlet. The church was built in 1885 and still serves the community.

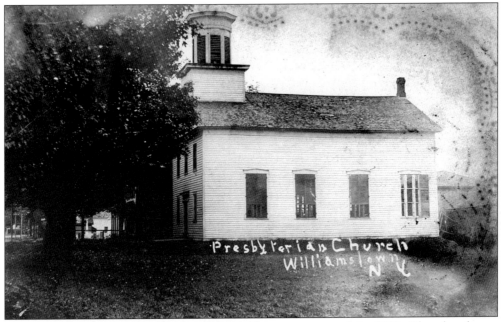

The c. 1840 Presbyterian church, on Main Street, is pictured in 1908. The church was organized in 1815 and was active until it closed in 1942.

This farmhouse belonged to Dennis and Catherine O'Rourke *c*. 1900. It was located on Westdale Road (Route 13).

The O'Rourke barns were located directly across from the O'Rourke farmhouse, on Westdale Road. This picture dates from the 1930s.

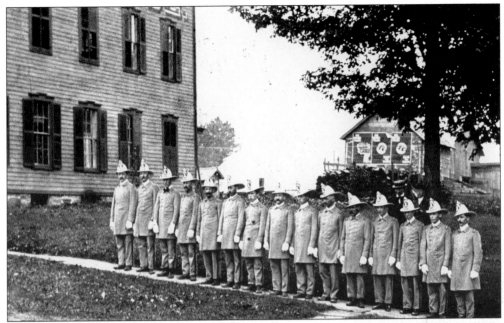

The Williamstown Fire Brigade is pictured next to the former Sage House on Friday, July 4, 1902.

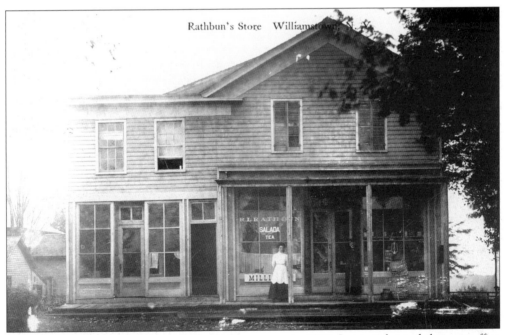

This Main Street building housed the Rathbun store in 1911. Later, it housed the post office on the left side and a Victory grocery store on the right. It was torn down in the early 1970s.

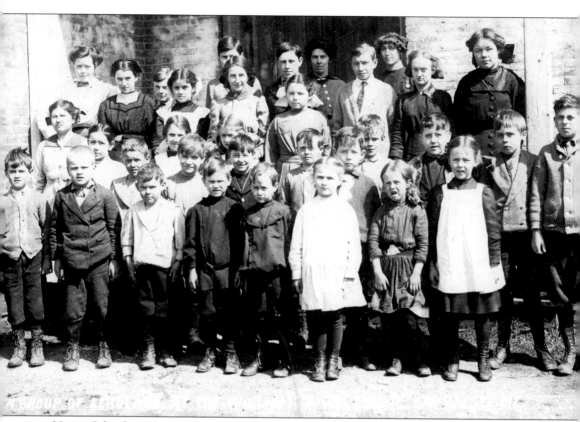

Union School pupils pose for a class photograph in 1912. The students are, from left to right, as follows: (first row) Francis Campbell, Andrew Smith, Ronald Kirkland, Richard Cooper, Harold Cooper, Laura Mahar, Violet Mowers, and Anna Healy; (second row) Genevieve Healy, William Kirkland, Edward Mahar, Frank Painter, Howard Campbell, Roger Healy, Claude Smith, Raymond McConnell, Llewellyn Frost, and Stanley Edick; (third row) Inez Mowers, Jennie Mahar, and Winifred Sage; (fourth row) Mary Campbell, Lillian Tanner, Mary Castle, Vida Brown, Austin French, Ethel Clark, and Barbara Haggerty; (fifth row) Clara Bray, James Hughs, John Nichols, and Lloyd Scanlon. The teachers are Jennie Leigh and Sarah Case.

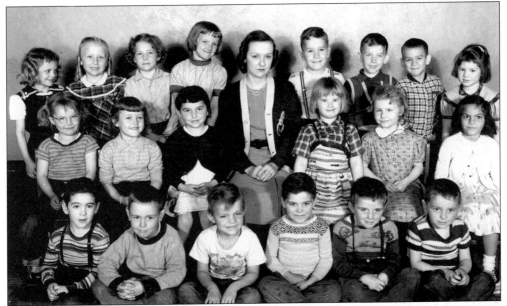

This photograph of Williamstown grade students was taken on April 21, 1955. The students are, from left to right, as follows: (front row) John McNamara, Robert Stamps, Don Britton, Peter Carusone, John Eaton, and Brian Britton; (middle row) Bonnie Russel, Sharon Riley, Jean Bowdery, teacher Janet Stamps, Elizabeth Wilson, Sandra Landers, and Nancy Carusone; (back row) Sandra Smith, Judy Lawrence, Clara Brockett, Beatrice Finnerty, Richard Gorski, Mike Wright, Steve Britton, and Corrine Haines.

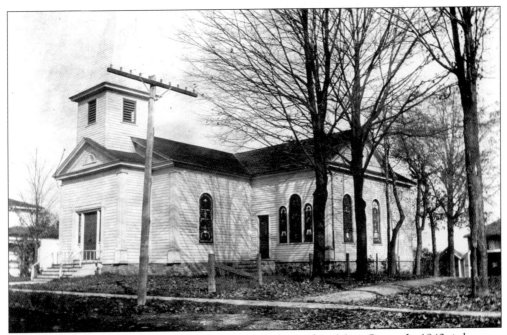

Shown in 1915 is the Methodist Episcopal church, located on Main Street. In 1942, it became the Federated Church, and in 1973, it was renamed the Union Church. It was closed in 1998.

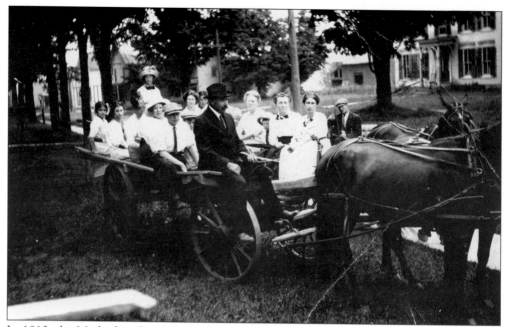

In 1913, the Methodist church had a hay ride to Kasoag Lake for a picnic lunch. The picnic goers included Lillian Tanner, Mary Campbell, Mary Ammann, Clara Ammann, Elizabeth Nichols and Mrs. Look (the Sunday school teachers), Pearle Huntly, Lloyd S. Nichols, and John Nichols (seen here driving the team).

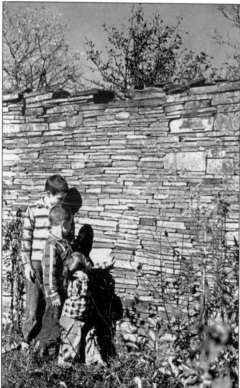

The Case Wall of Williamstown was built by the Jonathan Case, the uncle of Jerome Case, who went west to found a farm implement empire that still bears his name. The elder Case utilized the wealth of rock on his farm to build what many have called Tug Hill's Great Wall. It is said that, in its day, the wall was long enough and wide enough for Case to drive a team upon it in some sections. The meticulous eye of Case it seems was able to select just the right stones for each section of the mortar-less wall. The section in front of his home was 12 feet high by 6 feet wide. More than 125 years later, the wall still maintains much of its craftsmanship.

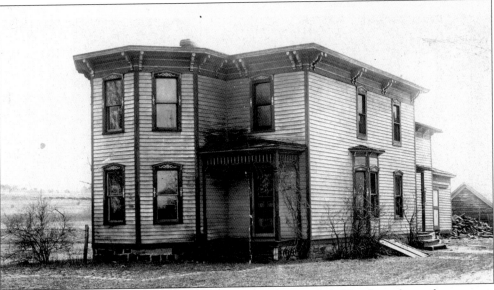

Shown are the residence and dairy barn of J.P. Healey c. 1910. The farm, located on county Route 19 (Maple Hill Road), is still a residence.

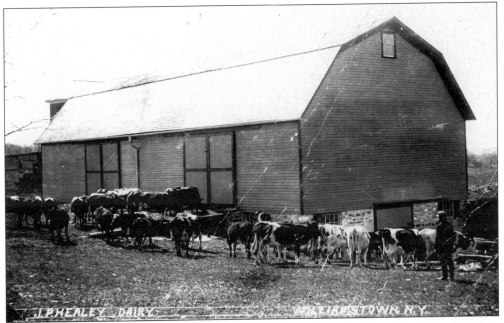

This is the J.P. Healey dairy in Williamstown.

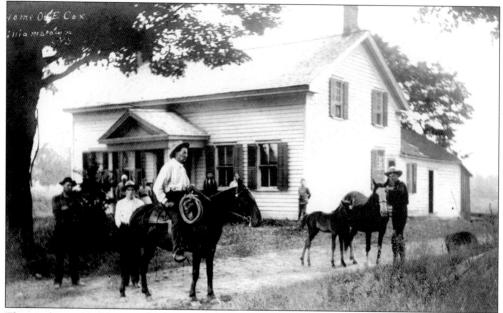

The residence of E. Cox was on Main Street in Williamstown. This photograph was taken *c.* 1910.

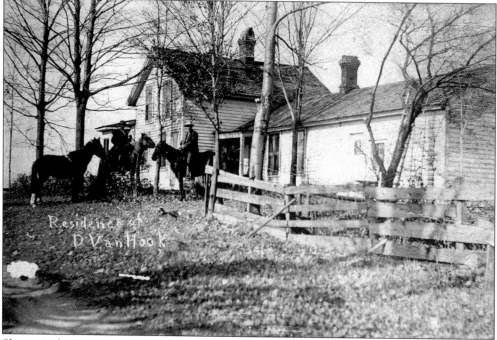

Shown is the D. Van Hook residence, located on Chilton Road in Williamstown.

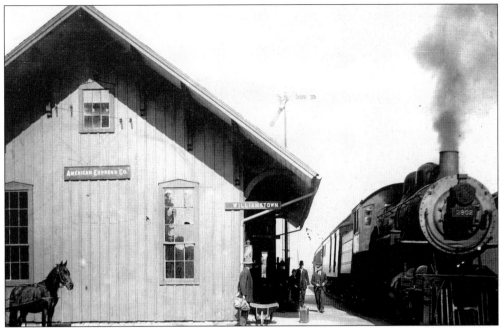

In Williamstown, the New York Central station was on Railroad Street. This view dates from 1915.

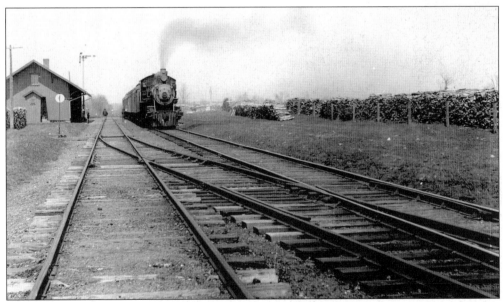

This c. 1910 view shows the New York Central station on what is today's county Route 30A in Kasoag. Note the piles of wood in the background that were used by the railroad.

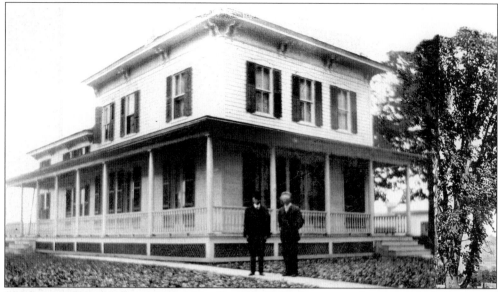

The home of John McGovern, on Main Street in Williamstown, is shown in 1906.

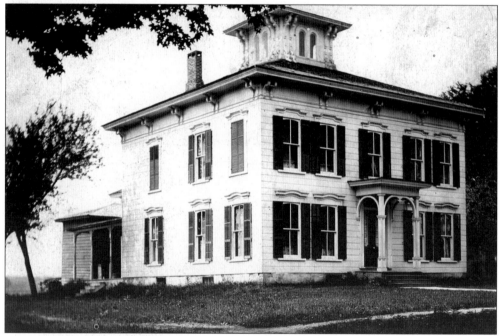

This home was built c. 1875 by Eli and Mary Castle. After Eli's death in 1900, the property was conveyed to his son, Eliott, and his son's wife, Lydia. Eliott Castle died in 1930, and upon his wife's death in 1936, the house was passed to their son, Watson. In 1937, it was rented to Harold Helms, who conducted a funeral parlor there until 1939. The property was then sold to a party from Buffalo, who converted it into several apartments. Martha Rood purchased the place and opened a bar and restaurant known as the Town House. Other owners include Hugh and Agnes Dowling, Bill DeSilva, Fred and Arlene Schweizer, Bob and Fern Brown, Russ and Rosemary DeGellke, and Norm and Flo Johnston. Later owners were Steve and Kathy Furgal. The building was destroyed by fire in 1992.

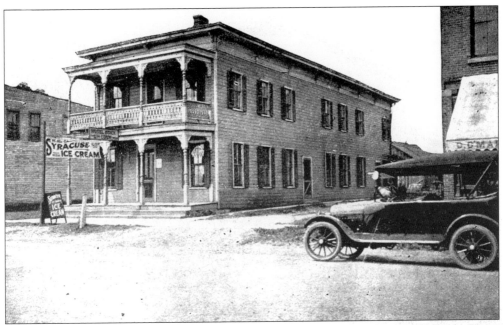

A 1920 view shows Hotel Edick, which was later known as Chamber's Hotel. The Main Street building was reduced to one story after a fire in 1960. It was torn down in the early 1980s.

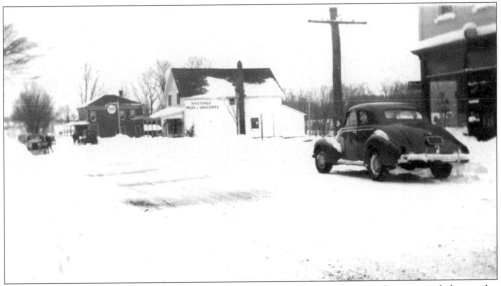

The Hastings store was located on Main Street. In this c. 1946 view, the automobile on the right is parked in front of the E.H. Gorman hardware store.

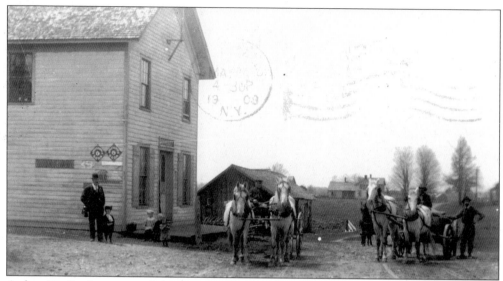

Arthur W. Presley operated this store in Kasoag, which was on the railroad and was once a bustling settlement. Today, Kasoag Lake is a small resort area.

Shown is Lakeview Farm in Kasoag. E.C. Bailey was the proprietor. This farm encompassed most of the land now subdivided into smaller camp lots along Kasoag Lake.